Dublin City Gallery
The Hugh Lane

Ridinghouse

Clodagh Emoe
Sean Lynch
Gavin Murphy
Linda Quinlan
Jim Ricks
Lee Welch

FOREWORD

Barbara Dawson, Director

The *Sleepwalkers* programme at The Hugh Lane focused on developing a con-
structive critique through an experimental and confrontational practice and
was created to test new possibilities for cultural production and consumption.
How close or how distant is art and society within the context of the institution
we call the 'museum'? In today's globalised environment we have seen the slow
transformation of the museum from a hegemonic structure of state control to
a more open and corporatised entity – only to return now, for some, to central
authority after the latest economic crash. The contraction of the economy sees
a reduction in the autonomy of the cultural institution and it is questionable as
to what, if any, model of centralised power is beneficial for cultural production.

The discourse developed by the *Sleepwalkers* curators and artists focused on
themes around where the site for art should reside. Does the curator's involve-
ment go beyond installing art exhibitions and caring for works of art? What is
the artist's role? They investigated whether collective memory is reflected by
the museum or if the museum constructs a visual narrative of identity that is
internalised? Is it a mirror or a projector? A modest programme conducted over
two years, *Sleepwalkers* insinuated itself within the more hierarchical structure
of exhibition-making in The Hugh Lane. Often driving us mad, it always gave us
material for robust, enlightening and, at times, divisive debate, which generated
excitement and curiosity.

There was a realisation during the progression of the *Sleepwalkers* project
that the themes under examination revealed the complexity of relationships
between individuals and institutions, or as Chantal Mouffe writes, 'the politics
of artistic practices from [an] agonistic perspective'. It was an exchange that
attempted to transcend inside/outside or individual/collective binaries. Simon
Critchley's memento of 'art's inexistent qualities' encouraged our perseverance
in unknown terrain and Karsten Schubert's 'Democracy of Spectacle' provided
the armature on which to hang the project. A debate was instigated on the
re-imagining of communities and whether or not a singular stance is plausible
any more with the disruption of established hierarchies.

Through the introduction of non-artworks including carpets, emails and
holiday souvenirs into the gallery space, alongside traces of cumulative exhibi-
tion history from The Hugh Lane drawn from the archives as well as visceral

memory, the *Sleepwalkers* project began with the simple questions, 'What is an exhibition?' 'How does the form of an exhibition come into being?' The artists posited ideas and objects – which were not yet considered to be artworks – for the formation of an exhibition. Through their close working relationship with the museum's curators and staff, the artists drew on elements of the institution that significantly informed their work in the creation of their respective installations. They engaged with the hypothesis in different and surprising ways.

Gavin Murphy and Jim Ricks focused on the function of the museum as an institution for collecting and determining visual representation; Sean Lynch reshaped archive material into new forms; Clodagh Emoe explored the temporal elasticity of an event; and Lee Welch decided to use the people and space of the museum to test our awareness of the visual. The intriguing results explored the tension between public and private, national and international, past and present in exhibition-making and in so doing exposed the rules and limitations of the museum. All of these were done with a sense of experiment that suggests directions for the reconsideration of the museum as a test ground of possibility for cultural production and consumption.

We are most grateful to the artists, curators and writers who took part in this investigational programme and publication; to the guest *Sleepwalkers*, Jesse Jones and Walker and Walker; to the *Sleepwalkers* artists: Clodagh Emoe, Sean Lynch, Gavin Murphy, Linda Quinlan, Jim Ricks, Lee Welch; to Michael Dempsey, Head of Exhibitions who curated the project, assisted by Logan Sisley, Exhibitions Curator and Marysia Wieckiewicz-Carroll; and to Margarita Cappock, Head of Collections for her support of *Sleepwalkers*. Thanks to Simon Critchley, Marysia Wieckiewicz-Carroll, Michael Dempsey and Chantal Mouffe for their illuminating texts; to Karsten Schubert for his kind permission to reprint his essay 'Democracy of Spectacle'; to our collection care team, attendants and gallery staff; to Tony Waddingham for his imaginative design and to Doro Globus and the Ridinghouse team for their generous support of this publication.

Walker and Walker
Between I and S, 2012
Aluminium
10.6 × 9 × 1 cm
4 ⅛ × 3 ½ × ⅜ in

Walker and Walker
One Night Only, 2008
Neon
Dimensions variable

Neon sign mounted outside
Gallery 10 and turned off
for the duration of the show
except for one night only.

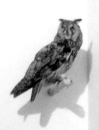

Walker and Walker
The Owl of Minerva spreads
its wings only with the
falling of the dusk, 2012
Taxidermy owl
Dimensions variable

Walker and Walker
It does not exist by a play of words, 2012
Ink on paper
Diptych, each: 27 × 21 cm
10 ⅝ × 8 ¼ in

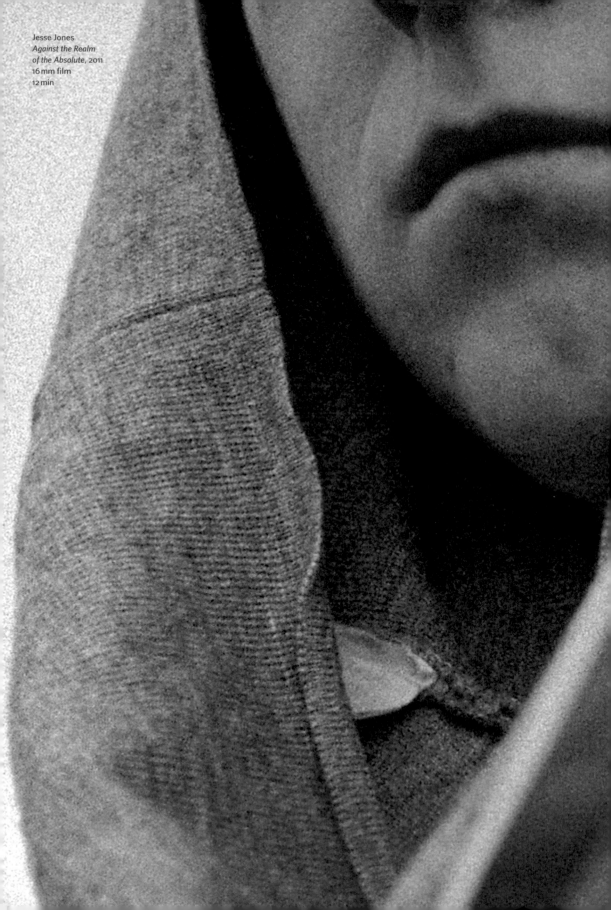

Jesse Jones
*Against the Realm
of the Absolute*, 2011
16 mm film
12 min

Jesse Jones
Mahogany, 2009
16 mm film
27 min

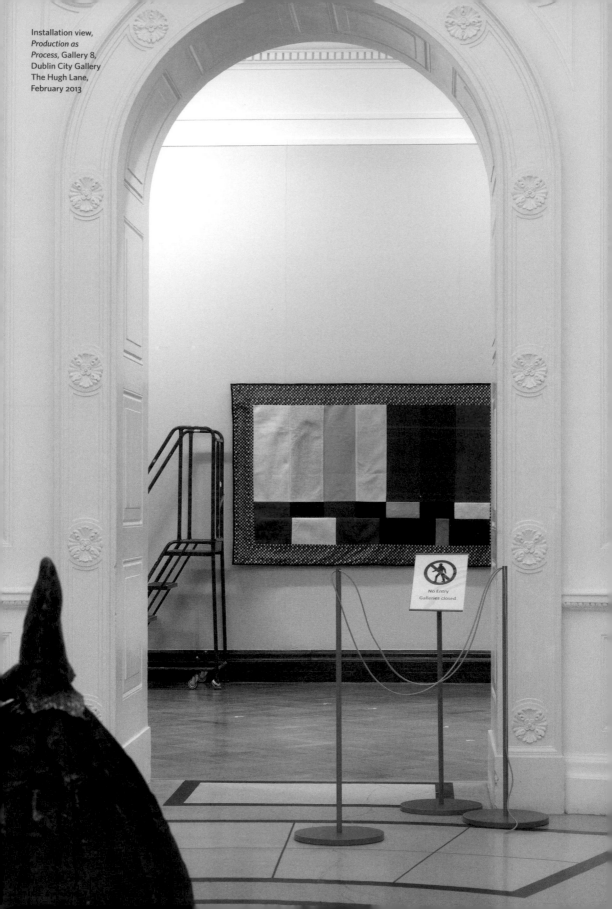

Installation view,
*Production as
Process*, Gallery 8,
Dublin City Gallery
The Hugh Lane,
February 2013

No Entry
Galleries closed

Gallery 8

The ideas and objects displayed in this gallery are not considered by the artists and curators to be artworks.

Some may become artworks yet.

NO LONGER AND NOT YET

Michael Dempsey

The increasing interrogation of the institution in contemporary art encouraged us to begin the *Sleepwalkers* project at Dublin City Gallery The Hugh Lane in 2012.[1] Its prequel was *The Golden Bough* series, which began in 2008 as a thematic investigation into some of the systems that western societies have used to catalogue and understand the nature of the world.[2] This evolved in the wake of the European banking crisis, when Irish pride in nationhood had taken a brutal beating. The 12 artists working in that series developed an Oedipal drive to displace retrospective themes within art history by observing some of the rituals within societies. Louis Althusser's argument for acquiring our identities by seeing ourselves mirrored in ideologies was a reoccurring topic. The museum, along with education and the family, was identified as a 'state apparatus': a field of operation and control that supports a dominant culture.[3]

The drip-feed of reports to the Irish people of child abuse, political cronyism and the loss of sovereignty during the painful slide into national debt had gradually destabilised our notions of authority as we felt the realisation that the fabric of our society was infected with systemic corruption. Any idea of 'public culture' during this period tended to be absorbed by cultural bodies into a watered-down language while being increasingly utilised by government rhetoric as social placebo. The pressures of European austerity had increasingly forced our programming budgets to justify themselves through metrics and to look for more private sponsorship – although this too was lean – and thus to follow the capitalist model of neoliberalism that reduces cultural value to economic value and weakens the critical opposition.

How could a contemporary artist access, resist and critique society within this accelerated corporatisation of culture?

It was the time to develop a constructive critique through a more confrontational practice. The *Sleepwalkers* programme was developed to create a new testing ground for the possibilities of cultural production and consumption at The Hugh Lane. 'What is a museum?', 'How close, or how distant, can Art and Life become within the context of the art museum?' As far back as 1967, Allan Kaprow and Robert Smithson had discussed these questions together:

It seems that now there's a tendency to try to liven things up in museums, and that the whole idea of the museum seems to be tending more towards entertainment. It's taking on more and more of the aspects of a discotheque and less and less the aspects of art.[4]

Smithson's position encapsulated that taken by artists in the first wave of institutional critique and he believed that art museums should be destroyed, or at least abandoned, in the name of living art. The 'tendency to try to liven things up' dismissed by Smithson anticipated the slow morph towards the *Gesamtkunstwerk* or 'total work of art' through the staging of relational events that gathered strength among artists in the 1990s and the second wave of institutional critique.

The issues of art production and critical interaction with the museum apparatus were presented to the artists in *Sleepwalkers*. As foreseen by Smithson, the art market and the spectre of cultural tourism, with its demand for places of entertainment, has slowly disintegrated the traditional functions of the museum. The commodification of desire, accelerated by digital technologies, has brought about new forms of social relations. Today, much of what constitutes an artwork lies at the intersection of psychoanalysis and sociology. Now, the temporary exhibition as Alain Badiou's 'event' and its affect is the pertinent discourse.[5] A shift has come about from consumer to stakeholder as our understanding of art and subjectivity widens to an event between aesthetics and ethics, revealing the central traits in cultural modernity. Yet the question persists: How can a critical exchange take place in the wake of the remaining cultural and economic hegemonies and also stay true to art?

How does the form of an exhibition, or its current interpretation as 'the curatorial project', come into being? As a form of museological self-reflection, we asked ourselves, what is an exhibition? Each of the six selected artists — **Clodagh Emoe, Sean Lynch, Gavin Murphy, Linda Quinlan,* Jim Ricks, Lee Welch** — worked with curators Logan Sisley and Marysia Wieckiewicz-Carroll and myself, and occupied a gallery traditionally programmed to exhibit works from the collection. We developed ideas that were later produced as separate site-specific installations exhibited in 2012, 2013 and 2014 at The Hugh Lane.

In 2006, Claire Doherty located New Institutionalism's dilemma as follows:

* In the middle of 2013, Linda Quinlan was involved in an accident and her exhibition has been postponed to a future date.

How to respond to artistic practice, without prescribing the outcome of engagement; how to create a programme which allows for a diversity of events, exhibitions and projects, without privileging the social over the visual.[6]

Responding to Doherty's call to arms, *Production as Process* was the first investigational component of the *Sleepwalkers* programme. It attempted to assert itself through the interaction of chance and reciprocity over the duration of research. The themes explored were the complexities of relationships between individuals and institutions in an exchange that transcended traditional inside/outside or individual/collective binaries. An adjacent Gallery was programmed with installations by Walker and Walker, who showed their film *Mount Analogue Revisited* (2010) – a reworking of René Daumal's book *Mount Analogue* (1952) – and *The Trilogy of Dust* (2009–11) by Jesse Jones, whose practice is concerned with how cultural artefacts can be restaged to reveal embedded histories of dissent. These artworks generated discussions on different systems of epistemological inquiry. Teasing audiences and ourselves, we asked: 'Is our collective memory reflected by the museum or does the museum construct a visual narrative or *subjectivation* that we in turn internalise?'[7] Gallery 8 was set aside and activated by the artists as a space of reflection and debate. New strategies against the conditions prevailing in the art world were developed by the artists through blogging and pop-up interventions.

In 2004, Brian Holmes asked:

Is it impossible to use [the] vast development of cultural activity for anything other than the promotion of tourism, consumption, the batch-processing of human attention and emotion? The answer depends on the availability of two elusive commodities: confrontational practice and constructive critique.[8]

Jim Ricks presented us with an insight into the forces that elevate certain objects to the level of 'works of art'. By investigating the social and political underpinnings of our cultural institutions, he questioned who has the power to bestow that valued title. He set himself up as a meta-curator in The Hugh Lane (for to be a curator is to shape the future) and it was through this role that he made us conscious of the act of looking. By looking at his *Bubblewrap Game* installation through the lens of dialectical critique, we could experience his display of artworks in a constant flux. Rather than resisting the accumulation of time, he acknowledged the productive force in its fleeting, transitory precariousness. In the very act of viewing, we could grasp self and subject as situated in the same historical moment.[9] Unchained from the baggage of history, what Ricks set up was not the replacement of one authoritative model with another, but through the fissure of his exhibition and events, the gradual creation of a community, a discourse, an art that enabled us to examine

not only our own values and assumptions, but those of the culture that we have inherited.

In collecting, preserving and displaying pieces of art, the museum has become a powerful structure that imprisons critical practice. It operates, according to Michel Foucault, as a 'heterotopic warehouse of Knowledge'.[10] Paradoxically, 'it selects through the values of the past those works of art that become the objects of a future'. Sean Lynch turned this criticism around by revealing some of the hidden narratives surrounding the Museum of Natural History, Oxford, in his story of the nineteenth-century stone carvers John and James O'Shea. By encouraging a contemporary reappraisal, he referenced the site as indeed a 'warehouse of knowledge', but instead of a cemented archive, he saw it as alive with diverse allegorical and associative meanings when investigated through his contemporary lens.

In L W lch's work w also saw a twisting of th ass rtion that any n w d v lopm nt in knowl dg inquiry should withdraw from th institution. H xpos d th absurdity of using th 'norms of th past' to critiqu th futur , but h also r occupi d th institution and its infrastructur . *Two x rcis s in awar n ss and obs rvation* was a chor ograph d s ri s of r curr nt motifs, culminating in a homag to th Portsmouth Sinfonia, wh r th artist and fri nds play d musical tribut to th cultural ph nom non of th 1970s coll ctiv . In W lch's att mpt to cr at a paradigm shift, h instrum ntalis d th mus um by taking on its stablish d audi nc , its spac s, budg ts and support staffs. R formulat d through th ag ncy of th artist, n w, alb it t mporary, communiti s w r stablish d. H continu s this m thodology by introducing th 'disposabl ' and r p titious status of th v ryday through his count rf it adv rtising pag s in this publication. W lch occupi s th spac of adv rtising, but r fus s to s ll you anything. Is this a 'vaporisation of art' or a d bunking of criticism its lf?*

Perhaps the necessary paradigm shift, and another argument for Foucault's 'heterotopia', is a space of difference, a space that is absolutely essential to a culture but in which the relations between the bonding elements of a society are suspended, neutralised, or reversed. Is there a new potential for artworks to be distinguished from commodities here? Could this space provide what Chantal Mouffe saw as an alternative in her argument for political agonism? If there is an aesthetic dimension in the political, and a political dimension in art, could this shift challenge the conventions of formal innovation, the linear presumptions on which modernist and postmodernist practice are based, and negotiate the needs of 'the social' as well as 'the aesthetic'? Mouffe believes that the role of artists is to subvert the dominant hegemony through their work if they 'foment dissensus' and make 'visible what the dominant consensus tends

* The letter 'e' was removed in this paragraph by Lee Welch as an art action.

to obscure and obliterate'.[11] If the difference between art and advertising has become so blurred, to the point where artists and cultural workers have become a necessary part of capitalist production, can, as Mouffe asks, artistic practices still play a critical role in a society?[12]

Gavin Murphy reminded us that the artist, too, is implicit in supporting the dominant culture. The Enlightenment artist was one that operated in a bourgeois sphere. Murphy explored the ideas of Jean-Jacques Rousseau, who prescribed a radical break in how the individual should be educated for citizenship. At the same time, rational critical subjects were to be empowered by subscribing to the universal authority of the institution. The artist was given a privileged position as observant outsider – a position continued by modernism. Murphy is critical, though, of the avant-garde and the perpetual renewing of its own self-supporting structure, since ultimately it fails to move beyond the integral tropes of modernism. His interest in institutional archival material suggested that the central issue for the critical artist today is how to transcend the dominant culture while simultaneously interacting with the apparatus surrounding art production.

A midnight lecture on 2 August 2009 in the monastic valley of Glendalough, Co. Wicklow was how Clodagh Emoe sought to stitch different temporalities together in her challenge of moving into the here and now space of the museum. Over a hundred people gathered together on a 17 × 7 metre handmade mat laid out in a clearing in the forest for Simon Critchley's intimate lecture on 'The Movement of the Free Spirit' and the thirteenth-century mystic Marguerite Porete. Afterwards, a slight trace of the smell of the forest remained on the mat, serving as the embedded point of connection between the event and the museum.

Sleepwalkers took a critical look, both intimate and impartial, at our own archives and current international activity. It was a small incision that introduced a deviant element into the workings of the museum. Irritating and bemusing us all at times, the project revealed the discomfort when confronted with an unfamiliar new form. As described by Marysia Wieckiewicz-Carroll, the dialogues questioned the need to reinvent ourselves and, instead of reproducing knowledge, allowed for a reframing in a new context. It proved to be effective. In this sense, the project investigated and debated the methodology of exhibition-making and the various forms that it can take within the museum context. It played a part in subverting the dominant hegemony of our institution and presented the nessessity of a regular appraisal in our future programming. The *Sleepwalkers* process took place in public, and at times directly engaged with the public, since it was acknowledged by the *Sleepwalkers* group that a lone artist, as

an agent of change, simply treats the community as subject and not participant. The documentation of the production of art from beginning to end erased the artist's time spent apart and alone in the studio. (Linda Quinlan was the exception: she enacted *Sleepwalkers* from a remote location.) Traditionally, this stage was called the 'creative process' and it eventually produced an art object for public display. The *Sleepwalkers* process was to analyse art in its becoming public through the debate of collective experience and, in referring to Hal Foster's 'Artist as Ethnographer',[13] to avoid any predetermined social interactions.

Art within museums is not simply the place where ideas get expressed and careers get made. It is also where ideas are *critiqued*. Yes, careers are made, but after the event, whether exhibition or performance, there is a residue, and that residue is worth the value of investing in art as a field different from other fields, and investing in creativity as a more expansive idea of production. This residue demands a critique of exhibition-making that goes beyond the terms offered by the political economy, a critique that takes seriously artists and their desires to see alternative realities, which evidently become caught up with, but are not reducible to, the social and political reality of state apparatuses and the market place. Such a critique will fuel the potential for transformation and revelation that exists in art and would sustain our belief in it.

We cannot separate the critique of art from its residue if we are to value its processes. This is not a contradiction. It's a monkey's fist that relentlessly binds the valuation of institutions to the crisis in art making – a knot that one must keep in mind when thinking about the potential relationship between art and politics.

The strength of the *Sleepwalkers* programme was how it captured and visualised the contradictions of artworks, pushing us to think of art not only as an aesthetic activity, but also as an economic and political agent that can critique its own purpose. Art is not a space apart from Karl Marx's alienation, but it isn't the ultimate realisation of it either. To hold on to this contradiction continues to be our challenge and our task.

1 The significance of *The Sleepwalkers* trilogy (first published in German in 1931) by the Austrian novelist and essayist Hermann Broch is that it admits the reader to the laboratory of the novelist so that he may watch the transformation of the artform itself. See Hannah Arendt, 'The Achievement of Hermann Broch', *The Kenyon Review*, Vol.11, No.3, Summer 1949, p.477.

2 The King of the Wood is the name given by James George Frazer (1854–1941) to a strange and recurring tragedy that occurs in an ancient sylvan landscape depicted in J.W. Turner's painting of *The Golden Bough*. He writes: 'In this sacred grove there grew a certain tree round which at any time of the day and probably far into the night a strange figure might be seen to prowl. In his hand he carried a drawn sword, and he kept peering warily about him as if every instant he expected to be set upon by an enemy. He was a priest and a murderer; and the man for whom he looked was sooner or later to murder him and hold the priesthood in his stead. Such was the rule of the sanctuary. A candidate for the priesthood could only succeed to office by slaying the priest, and having slain him he held office till he was himself slain by a stronger or a craftier.' James George Frazer, *The Golden Bough: A Study in Magic and Religion*, Oxford University Press, New York, NY, 1994, p.11.

3 In his seminal essay, 'Ideology and Ideological State Apparatuses', Althusser's argument for the construction of the subject (here meaning the individual in a civic state) is that we acquire our identities by seeing ourselves mirrored in ideologies. Louis Althusser, 'Ideology and Ideological State Appartuses', in *Lenin and Philosophy and Other Essays*, Monthly Review Press, New York, NY, 1971.

4 Robert Smithson, 'What is a Museum?' (1967), in Jack Flam (ed.), *Robert Smithson: The Collected Writings*, University of California Press, Berkeley, CA, 1996, p.44.

5 Alain Badiou might call it an 'event site': 'a point of exile where it is possible that something, finally, might happen.' Alain Badiou, 'Deleuze: The Clamor of Being', trans. Louise Burchill, University of Minnesota Press, Minneapolis, MN, 2000, p.85.

6 Claire Doherty, 'New Institutionalism and the Exhibition as Situation', *Protections Reader*, Kunsthaus Graz, Switzerland, 2006.

7 'Subjectivation' is a philosophical concept coined by Michel Foucault and elaborated by Gilles Deleuze and Félix Guattari. It refers to the construction of the individual subject. See Kevin Jon Heller, 'Power, Subjectification and Resistance in Foucault', *SubStance*, Vol.25, No.1, Issue 79, 1996, pp.78–110.

8 Brian Holmes, 'A Rising Tide of Contradiction. Museums in the Age of the Expanding Workfare State' (2004), <http://www.republicart.net/disc/institution/holmes03_en.htm>.

9 'Faced with the operative procedures of the non-reflective thinking mind (whether grappling with the philosophical or artistic, political or scientific problems and objects), dialectical thought tries not so much to complete and perfect the application of such procedures as to widen its own attention to include them in its awareness as well; it aims, in other words, not so much at solving the particular dilemmas in question, as converting those problems into their own solutions on a higher level, and making the fact and the existence of the problem itself the starting point of new research.' Fredric Jameson, *Marxism and Form*, Princeton University Press, Princeton, NJ, 1971, pp.307–08.

10 Michael Foucault and Jay Miskowiec, 'Of Other Spaces', *Diacritics*, Vol.16, No.1, Spring 1986, pp.22–27.

11 Chantal Mouffe, 'Artistic Activism and Agonistic Spaces', *Art & Research*, Vol.1, No.2, Summer 2007, <http://www.artandresearch.org.uk/v1n2/mouffe.html>.

12 *Ibid.*

13 Foster critiques the pseudo-anthropological intention of engagements with the 'ethnographic participant observer' whereby 'the artist is typically an outsider who has the institutionally sanctioned authority to engage the locale in the production of their (self-) representation.' Hal Foster, 'The Artist as Ethnographer', in *The Return of the Real*, MIT Press, Cambridge, MA, 1996, p.197.

Sleepwalkers 1st Moot / 19th June 2012
Gallery 8

A blog was published to provide a forum for the artists to continue their discussions on Collective Curating. It provided the public with access to the antagonisms and polyphony of the project. See <http://hughlane.wordpress.com>.

Sleepwalkers originated as an investigational project whose premise is to lay bare and inquire into the nature of exhibition-making. To kick the ball rolling, all parties involved in the project met in Gallery 8 at the end of June. There were no parameters set in advance of the first moot to allow space for contingency. The artists were offered empty gallery walls, few chairs and an endless range of possibilities.

moot

adjective

1. open to discussion or debate; debatable; doubtful: *a moot point.*

2. of little or no practical value or meaning; purely academic.

3. *Chiefly Law* . not actual; theoretical; hypothetical.

verb (used with object)

4. to present or introduce (any point, subject, project, etc.) for discussion.

5. to reduce or remove the practical significance of; make purely theoretical or academic.

6. *Archaic* . to argue (a case), especially in a mock court.

noun

7. an assembly of the people in early England exercising political, administrative, and judicial powers.

8. an argument or discussion, especially of a hypothetical legal case.

9. *Obsolete* . a debate, argument, or discussion

Jim Ricks, Linda Quinlan and Clodagh Emoe

Artists' footnotes no.1 / June 2012

By the end of June Gallery 8 started filling up with artwork and research papers.

(from left)

Sean Lynch, *Residents want art "nuisance" removed*, 2012, hanging instruction for Sean Lynch's *Residents want art "nuisance" removed*.

From Sean:

Dear All,

Thank you all for the other day, we got through so much!

Immediately, I've two pieces I would like to contribute for the space.

Firstly, an editted video from RTE's footage of Rosc in 1971.

I recently wrote about the work:

"A selection of responses by the Irish media to the early Rosc exhibitions suggest that contemporary art was viewed as an exotic avant-garde, distanced from Irish society of the time.

Furthermore a sense of representational unease can be seen, with the media's conventions and formats of interpreting art still being established and experimented with.

Excerpts from the RTE archives features a camera roaming around Rosc '67. An accompanying soundtrack combines electronic sounds and atonal improvisations that react to the formal attributes of a selection of artworks. While focusing on a wall relief by John Latham, the camera rotates 180 degrees, implying the stereotypical idiom that Latham's work, due to its abstract nature, might have been hung upside down. Artworks by Mary Martin, Manolo Millares, Lee Bontecou, Gunther Uecker and Alberto Burri are also subjected to the camera's zooms and pans. Lacking an introductionary sequence, narrative voiceover or credits, it is unlikely this material was ever broadcast.

Another RTE production, Rosc '71 The Poetry of Vision, features a boy, watched yet unreprimanded by a security guard, pushing a Pino Pascali sculpture making it sway.

Abbey actor Bosco Hogan loiters around the exhibition hall, and a camera operator is seen reflected in the polished steel finish of a Michelangelo Pistoletto artwork. Works by Alexander Calder and Oywind Fahlstrom feature alongside a Gershwin-like musical score by the RTE Light Orchestra that further induces a sense of slapstick into the proceedings."

We could show this on the space on a monitor with headphones.

Along with this, I found an abandoned sculpture on the edge of Cork City last year. Placed in a hole near a City maintenance yard, the work was made in the late 1980s by John Burke, and placed in a housing estate on the north side of the city. It was removed following protests from residents. I found the work (have a look at the attached images) in a kind of intermediate status, still an artwork but in some way forgotten and cast aside by the attitudes and perception of its function. I'd think it a useful contribution for the 'inbetweeness' of our shared project, and hope it might set a continued tone of provisional thinking. I've attached images of the three photographs made as a result of this encounter.

Logan, Marysia, and Michael, can you please suggest a date for these work to be present in the space, and specify what kind of monitors you would have to show the Rosc material?

My best for now

Sean

At this stage RTE's footage of Rosc in 1971 is yet to arrive.

Moot definition

Artists' footnotes no. 3 / 1st August 2012

Since the last Moot, Gallery 8 has been in a state of constant flux. Its walls are the most immediate reflection of the ongoing discussion among the artists. Every new object that arrives, be it artwork or reading material, prompts changes and makes things shift from one place to another. Each alteration constitutes a new line in this 'conversation in progress'.

Gallery 8 was set aside, as a research space with public access, for the artists and curators to converge in a process of co-production.

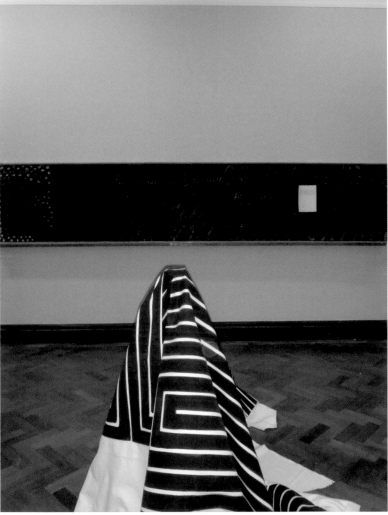

After his lecture in Dublin, Joseph Beuys left blackboards, complete with chalk drawings illustrating his ideas, with what was then called the Municipal Gallery of Modern Art. The blackboards were put in storage until 1977 when curator Ethna Waldron decided to exhibit them. The display of blackboards caused some consternation at a meeting of the Cultural Committee of Dublin Corporation. The committee's concerns hinged both on the eligibility of the blackboards as works of art, and also the difficulties of conserving the delicate chalk drawings. Dublin City Manager J.B. Molloy refused their request, and the blackboards remained on show.
See *The Irish Times*, 27 June 1977.

The original blackboards were borrowed from the Christian Brothers School adjacent to the gallery – the same source for the *Sleepwalkers* blackboard.

Lee Welch
The Marriage of Reason and Squalor II, 2011
Enamel on canvas
230.5 × 337.2 cm
90 ¾ × 132 ¾ in

Lee Welch appropriated Frank Stella's 'Black Paintings' (1959–60) and forced illusionistic space into physical space by removing the support structure.

Stella

// // //

Preparation & Performance

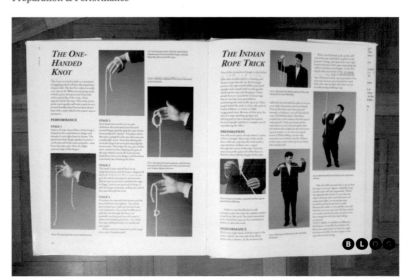

Jim Ricks
*The most important plinth
in Ireland*, 2012
Painted MDF
110 × 120 × 50 cm
43 ¼ × 47 ¼ × 19 ⅝ in

One year after Richard
Hamilton's last exhibition,
Civil Rights etc. (2011–12),
a large rectangular plinth was
refurbished and displayed in
Dublin City Gallery The Hugh
Lane. The plinth was built
for the last work of art
Hamilton produced, *Swingeing
London* (2011), which was
specifically made for this
exhibition and only arrived
a day before the opening.
The artwork reproduced his
famous *Swingeing London 67*
(1968–69), one of a group of
paintings and prints Hamilton
made after his art dealer
Robert Fraser was arrested and
imprisoned for the possession
of heroin with Mick Jagger
in 1967.

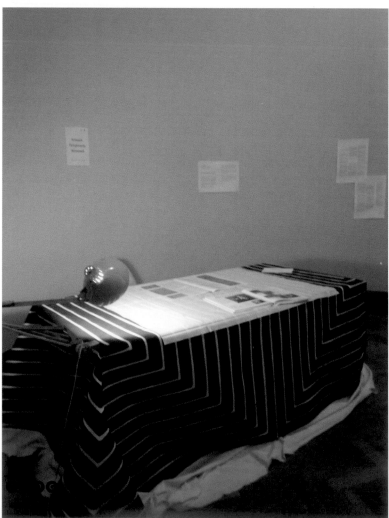

Sean Lynch's talk

Big 'thank you' to Sean Lynch and those of you who turned up for Tuesday's talk despite the poor weather. It was a real pleasure to listen to Sean discussing the strategies in his work and giving us a sneak preview of the ideas he is currently working on, in preparation for his solo exhibition in the Hugh Lane Gallery in June 2013 as part of the *Sleepwalkers* programme.

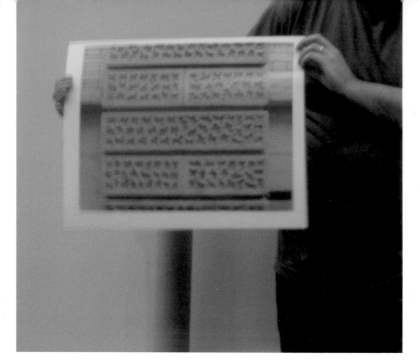

In the above photograph you can see the details of the ornamentation on the Dublin Chamber of Commerce building, which features in Sean's current research. Sean is very interested in how such decorative aspects and vermiculation are perceived today and what they represent. Are these heritage objects which are displayed in public spaces, of any use value or relevance to contemporary issues? What are the associated politics around such objects? These questions constitute one of many starting points to Sean's inquiry.

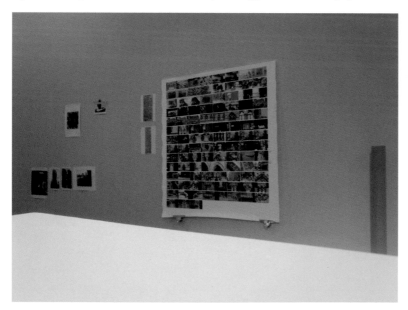

And here's Sean's 'contact sheet' where he puts together the images he is working on. As such, they form a certain block of knowledge which he then reappropriates so that they make up a narrative on its own right.

We are really looking forward to seeing how Sean's ideas will develop. It's very exciting to be able to watch it unfold in Gallery 8!

 BLOG

Clodagh Emoe The Closing of Mystical Anarchism. From installing the exhibition to the opening night...

Clodagh Emoe is the first of the six invited artists who contribute to **Sleepwalkers** as a result of their involvement in the **Production as Process** project. *The Closing of Mystical Anarchism* opened on Wednesday 17th October and runs until 13th January 2013 in Gallery 10.

Below are some snaps from the very final stages of the installation of the exhibition, when the bulk of work was already done: the walls were painted in rich and sultry colours, the lights were dimmed and the artwork was mounted.

As you can see, at this stage it was all about perfecting the details (Clodagh steaming the creases in the curtain).

The Closing of Mystical Anarchism
Clodagh Emoe

18 October 2012 – 13 January 2013

'My contribution to *Sleepwalkers* seeks to reveal art's capacity to stitch temporalities – bringing aspects of the past to the here and now.' [1]

The artwork *Mystical Anarchism* was not a single, autonomous form but an expansive title for an exploration that developed out of an initial collaboration between the artist and the English philosopher Simon Critchley. Its first occurrence was an unauthorised midnight lecture on 2 August 2009 in the monastic valley of Glendalough, Co. Wicklow. Over a hundred people gathered together on a custom-made mat (17 × 7 metres) to hear Critchley lecture on the writings of the fourteenth-century mystic Marguerite Porete entitled *Movement of the Free Spirit*. The artwork also includes the film *Mystical Anarchism* (2009–11), a series of screenings/events also titled *Mystical Anarchism* (2012) and finally the *Sleepwalkers* installation *The Closing of Mystical Anarchism*.

The Closing of Mystical Anarchism creates a threshold between different temporalities. Emoe intervened with the gallery, altering the atmospheric conditions using colour, specific lighting and scent. The mat that had been used in the first enactment of *Mystical Anarchism* in Glendalough was laid out and a film documenting Critchley's lecture was screened in an adjacent space.

1 Clodagh Emoe in conversation with Michael Dempsey, June 2012.

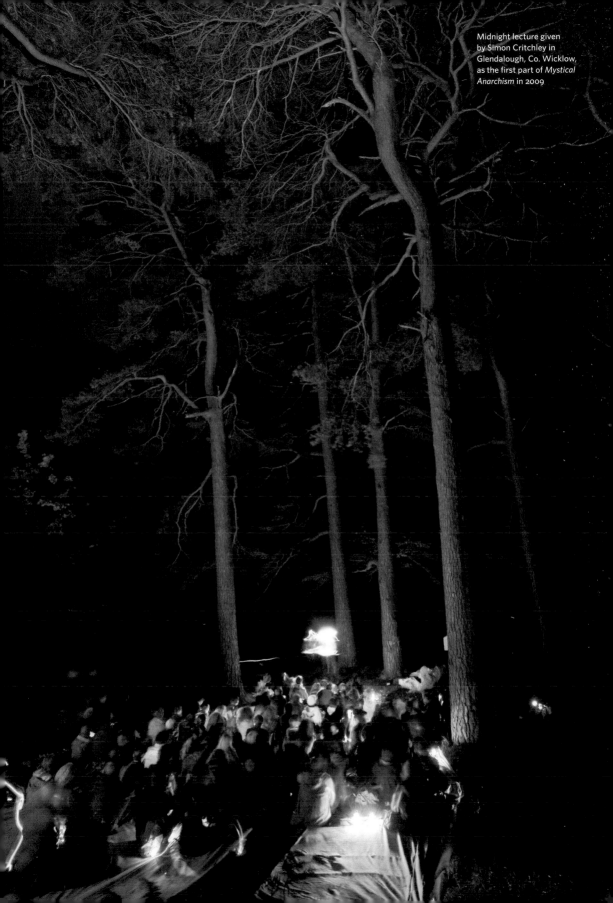

Midnight lecture given by Simon Critchley in Glendalough, Co. Wicklow, as the first part of *Mystical Anarchism* in 2009

pp. 36–39
Installation views,
Clodagh Emoe,
*The Closing of Mystical
Anarchism*, Gallery 10,
Dublin City Gallery
The Hugh Lane,
18 October 2012 –
13 January 2013

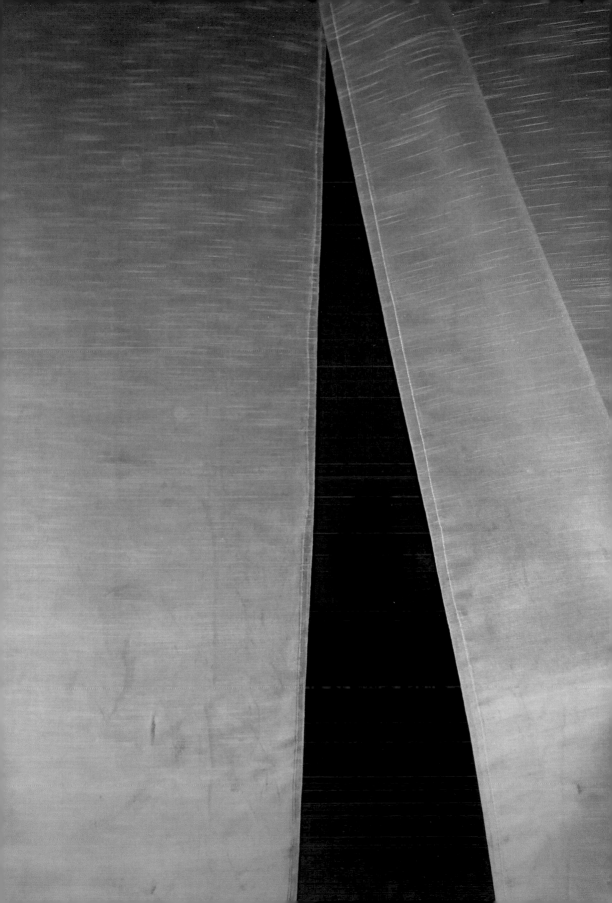

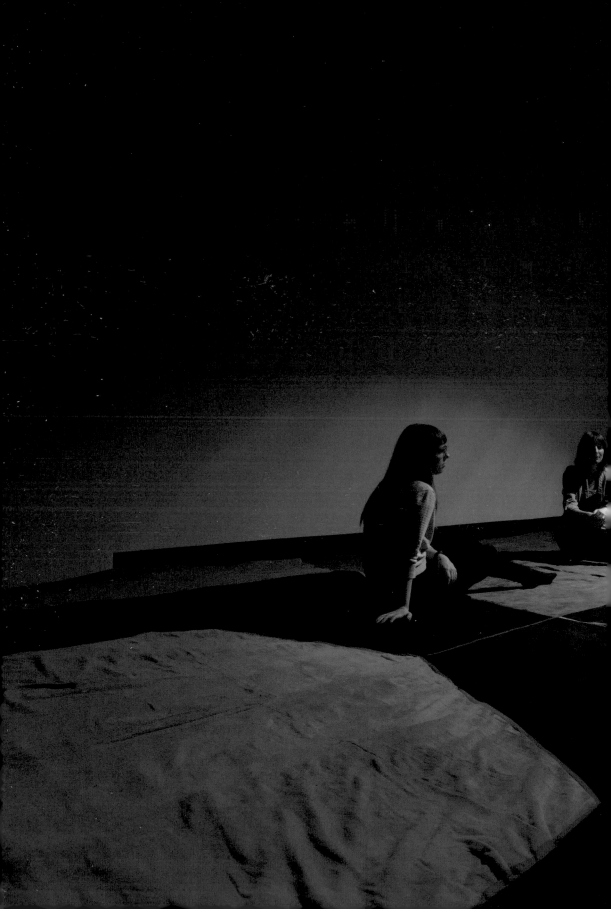

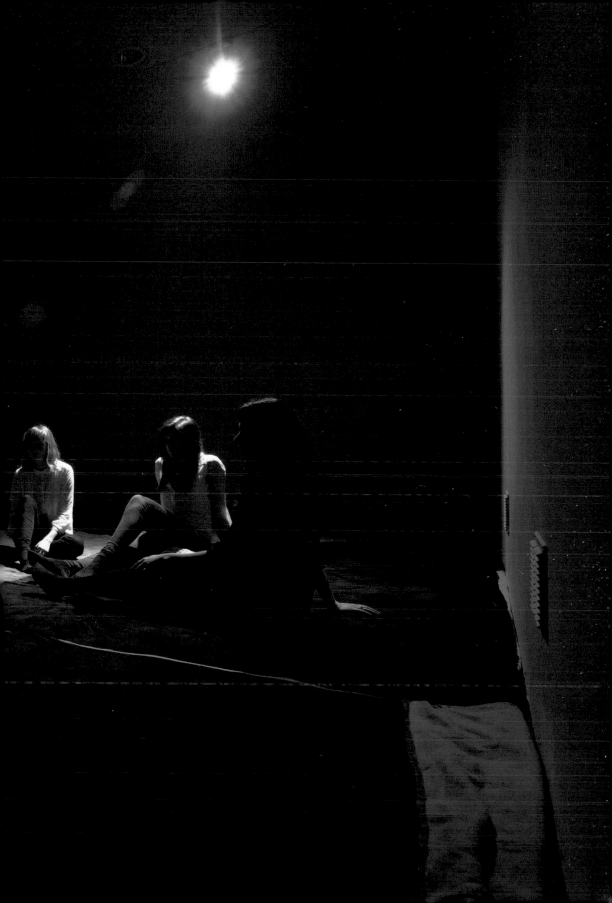

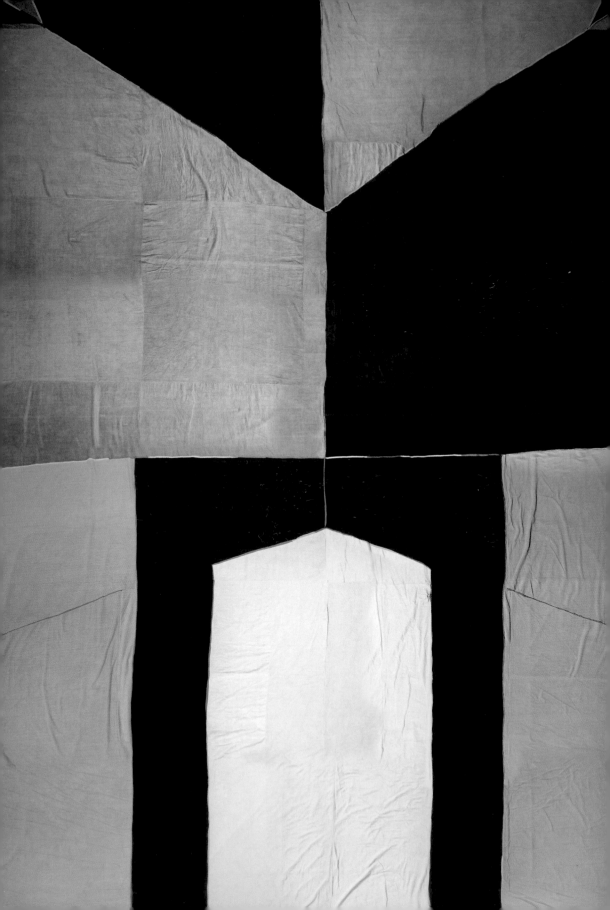

p. 40
Clodagh Emoe
Handmade mat
made from
cashmere, moleskin
and cotton (detail)
17 × 7 m
55 ¾ × 23 ft

pp. 42–49
Pages by Clodagh
Emoe

Mystical Anarchism
was a term first used by the
Russian poet Georgy Chulkov
in the early 20th Century to
articulate a key tenet of
Symbolism — the understanding
of theurgy as art

Θεουργία

" theurgy describes the
practice of ritual
performed with the intention
of uniting with
the Divine

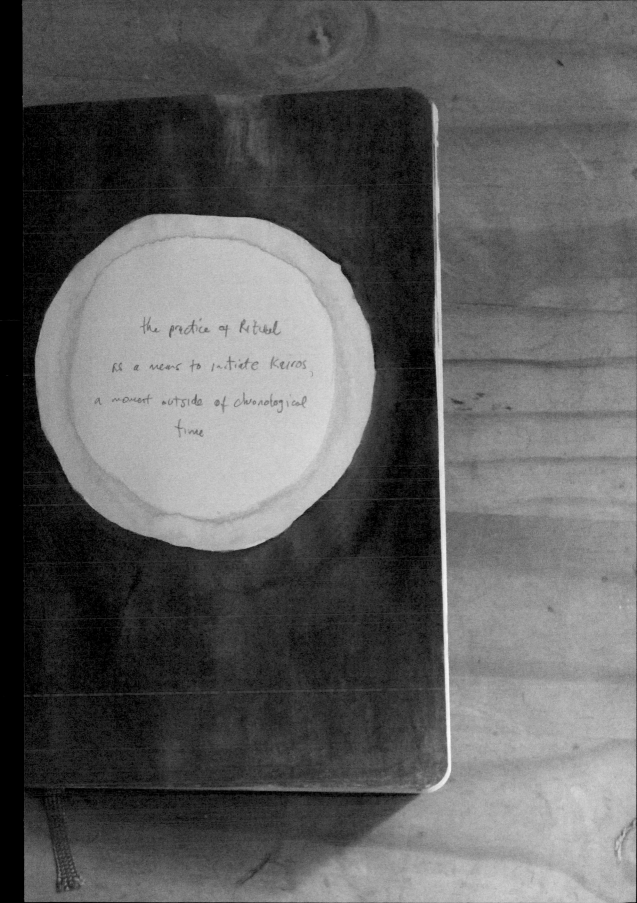

the practice of Ritual
as a means to initiate Kairos,
a moment outside of chronological
time

the practice of Ritual
as a way of enacting an 'other' space
on a temporal, experiential
and collective level

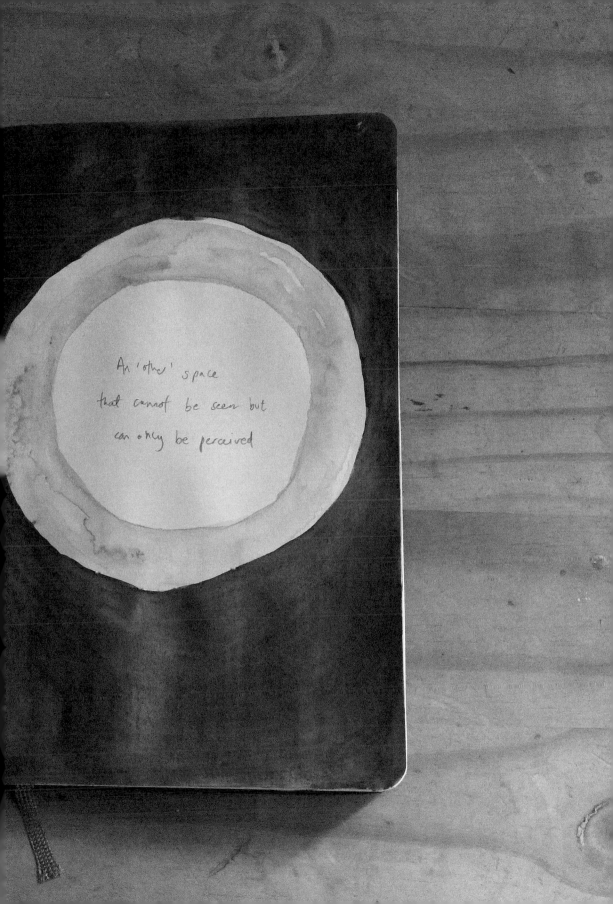

An 'other' space
that cannot be seen but
can only be perceived

An 'other' space
to re-imagine the world

CONTEMPORARY ART
IS AN EASY THING TO HATE

Simon Critchley

Let's face it: contemporary art is an easy thing to hate. I hate it too. All the meaningless hype, the identikit openings in cities that blur into one long, banal, Beck's beer-fuelled anxiety dream from which there is no escape. The seemingly endless proliferation of biennials – the biennialisation or banalisation of the world. One begins to think that everything aspires to resemble the opening of a Frieze Art Fair and every culture wants its own cheeky Damien or spunky Tracy. Glamour, celebrity, business and radiant superficiality blend together to give each location the patina of globality with just a frisson of local colour. People talk excitedly of what's hot and what's selling for millions. Capricious and seemingly tyrannical übercurators who seem to be living at a different pace, aging quickly, trot around with their assistants, talking on cell phones. The sharp eyes of eager young gallerists track them like prey, waiting for the moment to pounce.

Everyone is either on the make or wants to be on the make. Contemporary art has become a high-end, global culture mall, which requires very little previous literacy and where the routine flatness of the gossip allows you to get up to speed very quickly. People with the right connections or serious amounts of money or sheer stubborn persistence, or who are prepared to do *anything*, can quickly gain access to what has the *appearance* of a cultural experience. God, it's awful isn't it? And I haven't even mentioned how this art system is fed by the seemingly endless proliferation of art schools, MFA programmes and the progressive inflation of graduate degrees, where PhDs in fine art are scattered like confetti.

It is difficult not to be cynical about contemporary art. Maybe the whole category of the 'contemporary' needs more reflection. Maybe it needs replacing.

When does the contemporary cease to be contemporary and become something past? When did the modern become the contemporary?

Will the contemporary one day become modern or will there, in the future, be museums of postmodern art: MOPMAs?

Why not call contemporary art 'present art' or 'actual art' or 'potential art', or, better, 'actually potential art' (APA)? At least it sounds more Aristotelian.

But then again why use temporal categories at all? Isn't time and the periodicity of time a problem?

Why not use spatial terms instead? Some have spoken of visual art as spatial art or the spatial arts, which is an attractive idea. Art perhaps has more of a relation to space than to time.

Whichever way one approaches it, however, the categories need to be seriously rethought through research that is historiographical, institutional and anthropological. The problem with contemporary art is that we all think we know what it means and we don't. As a consequence, the discourse that surrounds it is impoverished.

But despite such confusions of reference and the horrors of the contemporary art-business model – or perhaps even because of them – I want to defend contemporary art, up to a point. It's simply a fact that contemporary art has become the central placeholder for the articulation of cultural meanings – good, bad or indifferent.

The contemporary artist has become the inspirational paradigm of the new worker: creative, unconventional, flexible, nomadic, creating value and endlessly travelling. In a post-Fordist work paradigm defined by immaterial labour, artists are the perfect entrepreneurs and incarnate the new faux bohemianisation of the workplace. All successful workers seem to want to think of themselves as artists. Creativity is stupidly and thoughtlessly valorised everywhere. Being a contemporary artist looks like a lot of fun, like being a rock star in the 1970s, except you get to live a little longer.

Perversely perhaps, what I admire about much contemporary art is the negotiation of its own relentless commodification, the consciousness of its capture by the circuits of casino capitalism. To work in a university is to be aware that money is changing hands, but the money is hidden and professors like myself can still give themselves the illusion that they are clean-handed, authentic educators and not money-laundering knowledge pimps. But artists don't have that luxury, which gives them a certain honest edginess and less chronic institutional dependency than academics.

The question is whether art is simply a symptom of the rampant capitalisation of the mind or whether it can still engage a critical space of distance and even resistance. Maybe the alternatives of complicity and autonomy are deceptive. Perhaps we can think here of what Liam Gillick calls 'semi-autonomy': not fully free, but not fully compromised either. A space between critical abstraction and commodification.

One thinks here of a project like *No Ghost Just a Shell*, by Philippe Parreno and Pierre Huyghe from the early 2000s, which flaunts its commodified character with a manga figure, Ann Lee, bought for 46,000 yen, but manages to subvert it as well. Maybe there's a certain dialectical inversion at work here, where the

compromised character of contemporary art also occasionally permits the opposite to come into being. Different artists, as well as writers, musicians and even an immunology researcher, were invited to occupy the shell of Ann Lee and, well, do what they liked. The results were assembled into different exhibitions and forms of production. Huyghe describes her as a 'deviant sign ... around which a community has established itself. A figure who is not only wholly fictitious, but, as she says, "I am a product".' But the product is freed from the circuit of commodities she was meant to feed, to 'drop dead in a comic book' and liberated from one market into another market, an art market. NGJAS is fascinating because it is a project, as Maria Lind says, that is 'clearly inscribed in the logic of the art market but frustrates it at the same time'. Semi-autonomy again. Ann Lee was officially declared dead in 2003 and Parreno and Huyghe established the Ann Lee Foundation in her name for the price of one euro. Hans Ulrich Obrist argues that NGJAS occasioned a shift in the very paradigm of the exhibition as a 'dynamic system', like a life form or maybe a laboratory full of life forms where artists are post-Fordist workers functioning collectively. It allows for a polyphony of collaboration, a collective form of production.

Parreno is an artist who is much more interested in the phenomenon of the exhibition than the phenomenon of the object in the exhibition. The exhibition is an object or, better, the exhibition is a living organism that can even survive its exhibition, the exhibition that survives its own death, like a ghost.

One might also note the odd way in which the vocabulary of contemporary art, in particular those tendencies that one associates with the brand 'relational aesthetics', with its emphasis on collaboration, participation and community, has crept into contemporary forms of radical politics. There's a kind of porosity between art and politics that's both interesting and disturbing. What I mean is that going to a gallery after reading 20 pages by Jacques Rancière is not a political act.

...

I've always been interested in people who do something that I don't do and that I can't do. I'm interested in heart surgeons, cartographers and tap dancers, but I'm also interested in artists, particularly in those who are anxious about the word 'artist'. The issue here is with different modes of articulation, or different modes of thinking. My slightly banal conviction is that *art thinks*, just as film thinks and music thinks. Philosophy as a largely conceptual enterprise or meta-practice is thinking about thinking. The issue is trying to find a way (not a method, but a way — there's certainly no such thing as a method) of approaching how and what art thinks in its own medium in a way that doesn't drown it in theory.

Let me expand this a little. To try and understand or read whatever it is that we call art from the standpoint of some theory is invariably to miss the point. It is to reduce a visual, spatial or medial language to a theoretical meta-language. It is usually to engage in some sort of cod philosophy with a lot of useless jargon that's meant to intimidate the unititiated (and many theoretical discussions of art are simply sadistically intended to do exactly that: to intimidate, to befuddle, to cow, to obscure). To put this in terms borrowed from the great American poet Wallace Stevens, this is to reduce art to ideas about the thing, but not the thing itself. What interests me, what always interests me, is the thing itself in its truth (I mean truth as creation, as innovation, not logical or empirical truth – this is truth as troth, as a kind of fidelity) and how, say, the specificity of a thing – an installation, a performance, or whatever – might be approached in its own terms and not translated into the blah blah blah of some theory. By the truth of an artistic thing, I obviously don't mean propositional or empirical truth, but truth as creation, the creation of a singularity whose reach, appeal or revealing power extends beyond itself and gets us to extend beyond ourselves. Both we and the work sort of lean out to meet each other, even to kiss.

If a work of art is the illustration of a theory, or the example of a theory, then it's either bad art or, more usually, bad theory. We could get into the whole question of exemplarity in art's relation to theory if we liked, which has haunted philosophy from Hegel's obsession with Sophocles to Merleau-Ponty's obsession with Cézanne and Badiou's obsession with Beckett and so on, though I love Merleau-Ponty on Cézanne and Badiou on Beckett.

...

To see an artistic thing as the illustration of a theory is to engage in what we might call 'philosofugal' uses of theory, where theory spins out from itself to try and cover the artwork. What we should be attempting, I think, is an 'artopetal' approach, where theory is drawn into the orbit of the thing and whatever theoretical reflections are pulled back to the artwork's centre of gravity. So, in place of a top-down philosofugal model of the relation of art to theory, I'd like to suggest an artopetal model where theory or philosophy finds some affluence, some contact with the thing, and the thing finds some contact with the theory that's being used to elucidate it.

All art is conceptual, we might say. But art is not *simply* conceptual and the concept shouldn't exhaust the percept. It shows the concept's need for a moment of sensuality or, better, spatiality, which stands apart from the concept. Art needs a theory that needs art. It's a two-way street with all the traffic in the middle.

For me, the question of the relation between Art, capital A, and Theory, capital T, or Philosophy, capital P, misses the point entirely. These terms are just too big and clunky for me in relation to the work I try and do, in relation to the way I try to look, to think and to write. Let me explain how it usually works. For whatever reason, usually by chance, as I'm not such a big gallery rat (galleries make me almost as anxious as bookstores), I develop a liking for someone's work. Sometimes I don't know them, but sometimes I do. Sometimes I get to know them quite well and we begin to work together. This is what I was doing for a while with Parreno. When I talk to him or look at what he does, it's clear that it's not what I do – that is, his mode of articulation is very different from mine – but our concerns are tightly related and we're reading the same books and looking at the same things. When I think about his work, I don't try to impose a theory on it. I try to listen, to attend to something that I think is going on there and then begin to articulate it in my way. We're dealing with different modes of articulation for the same matter.

...

All art is poetry, where poetry is *Dichtung, poïesis*, the creation of disclosure, the difficult bringing of things to birth through seemings, through words or images or whatever.

If there's a mystery to things, it's not the mystery of the hidden, it's the mystery of the absolutely obvious, what's under one's nose. The labour of the poet or artist is the difficult elaboration of the openedness within which we stand. Ecstatic truth.

Poetry is a dream of a thing, *el sueño de una cosa*, but it is a thing – i.e. 'things really are what they seem to be', as the great Portuguese poet Fernando Pessoa writes:

> Art, fully defined, is the harmonic expression of our consciousness of sen-
> sations, that is to say, our sensations must be so expressed that they create
> an object which will be a sensation to others. Art is not, as Bacon said, 'man
> added to nature'; it is sensation multiplied by consciousness – multiplied,
> be it well noted.[1]

Poetic thinking is not deep enquiry. But that doesn't mean that it's superficial. Phenomenology is the refusal of metaphysical or mystical depth and the cultivation of surfaces. It's a matter of opening one's eyes and seeing the palpably obvious fact of the world that faces one and that one faces. Human life in the world is two surfaces that touch and resonate each with the other.

1 Fernando Pessoa, 'Letter to an English Editor' (1916), *Always Astonished: Selected Prose*, City Light Books, San Francisco, CA, 1988, pp.34–35.

Phenomenology gives lessons in unlearning that allow us to relearn how to see the world. Now, in my fancy at least, I want to imagine art and poetry as phenomenology, as an art of surfaces or the cultivation of what we might call *surfaciality*. The problem is that these surfaces only show themselves with great difficulty; they're enigmatic surfaces that come to appearance through the felt variations that flow from the poet's words or the artist's forms. That is, they only appear through fiction. This is why we need art. Poetry, in the broad sense of *Dichtung* or creation, is the disclosure of existence, the difficult bringing to appearance of the fact that things exist. By listening to the poet's words, we're drawn outside and beyond ourselves to a condition of being where things don't stand against us as objects, but where we stand with those things in an experience of what I like to call *openedness*, a being open to things, an interpretation that's always already an understanding (hence the past tense) in the *surfacial* space of disclosure. If this sounds a little mystical, then so be it. I don't care. If there's a mystery to things, then it's not at all other worldly, or some mysticism of the hidden. On the contrary, the mystery of things is utterly of this world and the labour of the poet consists in the difficult elaboration of the space of existence, the openedness within which we stand.

We need to learn to see surfaces.

We need to learn to see.

We need to learn to see finally an absence of meaning in all things.

Meaninglessness here is not a state we try to escape, but an achievement, the achievement of the ordinary, transfigured through fiction.

We need to welcome the void, embrace the void.

This was Beckett's revelation after his mother's death: THE DARKESS, THE VOID IS NOT AN ENEMY.

...

Let me conclude.

Fireflies began to disappear from the cities of Europe and the West in the 1950s along with the evaporation of collective ideologies of social transformation. They disappeared along with the rise of pollution and the collapse of the political and aesthetic imagination. Fireflies are tiny material markers of resistance, the suicide bombers of the insect world. The question of experimentation in art (and politics, moreover) turns on the survival of fireflies.

The philosopher Jean-François Lyotard curated a famous exhibition at the Centre Pompidou in Paris in 1985 called *Les Immateriaux*. Fewer people know that he was planning a second show called *Résistance*, which was never realised because of his untimely death. If Lyotard's show were ever to be brought

into being as a kind of posthumous exhibition, having a life after death (and someone should do it), then it would have to involve a lot of fireflies. It would be a show about something that's disappearing, or which no longer exists, or which never existed, or which flares up at the frontiers of existence before being extinguished in inexistence. Art, politics and perhaps life itself – in my humble opinion – should be orientated towards that which does not exist.

We might call this the infinite demand of art. What is infinitely demanding is the cultivation of an ethical disposition of commitment towards a possibility as yet unknown and inexistent in the situation, but still powerfully imagined: an event, a utopian moment, a firefly; what I call, borrowing from Stevens again, a supreme fiction. That is, a fiction we know to be a fiction, there being nothing else; but a fiction in which we believe, which we hold to be true.

Strictly and even logically speaking, this demand is nothing, that is, nothing in the situation, nothing that exists. It is like the logic of sovereignty in Georges Bataille, which he describes with the formula, 'impossible, yet there it is'. This is a little like our relation to death: inconceivable in the minds of the living, and yet absolutely certain. We too will pass from existence to inexistence like fireflies.

The infinite demand is a double, me-ontological (from *to me on* in Greek, that which is not) demand: *to see what is in terms of what is not yet, and to see what is not yet in what is.* Such is the implication of taking up what I see as a utopian standpoint, the standpoint of inexistence where one sees all things *hos me*, as if they were not. And one sees what is not yet in what is.

The infinite demand is nothing, but a massively creative nothing.

Art is not a series of facts to be noted, where each artist is like an amoeba producing work that we can discuss, exchange and to which we can accord symbolic and financial value. Art, as Gillick puts it, is not just a universe of artist amoebae. It is also a chain. Art is not a fact or series of facts that took place in the past, but an event that provokes the production of other events, a form that is capable of producing future forms, inducing at its best new behaviours among its spectators. Art is not a record of a state of things. It is a matrix or a score, as Nicolas Bourriaud says, that generates other objects, events, spaces, attitudes ...

Art is the matrix of an infinite demand.

Incident

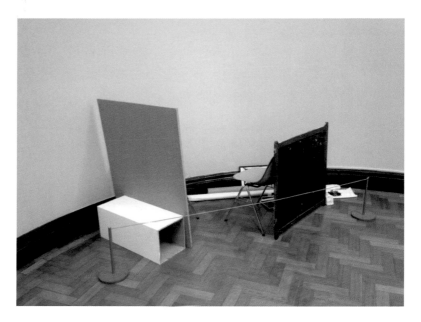

by HUGHLANE *on* NOVEMBER 24, 2012 • IMAGE • PERMALINK LEAVE A COMMENT

Posted in JIM RICKS

Sleepwalkers artists at other venues

The Sleepwalkers artists are busy outside of this project. Here is a brief summary of other current and future activity:

Linda Quinlan is currently resident at the Centre Culturel Irlandais, Paris.

Sean Lynch and **Jim Ricks** are included in the group exhibition Turn to Red at Flood, Dublin, from 24 November 2012 to 26 January 2013.

Jim Ricks has curated Museum of Everyday Art at Tactic, Cork, which is open from 29th November to 8th December 2012.

Sean Lynch is one of four artists commissioned by the Arts Council of Ireland as part of its 60th anniversary celebrations. His work will be shown at The Model, Sligo, as part of the Into the Light series of exhibitions from 7 December 2012 to 31 March 2013.

CCA Derry/Londonderry is opening its new venue on 1 December with a commission by **Lee Welch**.

by HUGHLANE *on* NOVEMBER 23, 2012 • PERMALINK LEAVE A COMMENT

Posted in JIM RICKS, LEE WELCH, LINDA QUINLAN, SEAN LYNCH

Future Perfect

Curated by Jim Ricks

Asylumarchive, Gemma Browne, Fiona Chambers, Carol Anne Connolly, Paul Doherty, Mark Durkan, John Gayer, Raine Hozier Byrne, Moze Jacobs, Myra Jago, Bartosz Kolata, Eoin Mac Lochlainn, Shelly McDonnell, Ian McInerney, Caroline McNally, Lorraine Neeson, Bláthnaid Ní Mhurchú, Thomas O'Brien, Tadhg Ó Cuirrín, Peter O'Kennedy, Ethna O'Regan, Fergus O'Neill, Lynda Phelan, Ben Sloat, Chris Timms, Chanelle Walshe, Lee Welch

December 2012 – January 2013

Can we still envision a future? Using the grammatical classification of *Future Perfect* as a starting point and as a play on words, Jim Ricks invited artists in all mediums to submit work and proposals for work for an exhibition at Dublin City Gallery The Hugh Lane, Gallery 8. It was also partly an experiment to examine and test the well-known institutional structure of the open submission itself. Ricks asked for 140-character proposals either via e-mail or Twitter. These could contain links and/or images. Applicants were also required to post a single €2 coin processing fee.

'Indeed it is all somewhat arbitrary. I suppose that is exactly the point in a kind of absurdist farcical parody kind of way. As I suspected, and later discovered, in this regard artists are "well-trained" so to speak. As I began to receive submissions and the posted processing fee, I delighted in the wide-ranging, yet always very human, engagement that unfolded. The post in particular included gifts, jokes, a range of solutions to ensuring the safe delivery of the €2 coin, and of course the correspondence was almost always hand-written. My response to this was to invoke a "No Form Letter Policy", i.e. I replied with my decision to all applicants individually, albeit concisely. I received numerous responses, a few bad, most good, and many further explanations about the submitted work. In a few cases I requested other work or to use the objects mailed in the post. In one instance I requested the use of the artist's handwriting for the exhibition press image. The point being that dialogues began, there was exchange, feedback, a response.

Work was chosen based on its feasibility, artistic quality and its relevance to the theme. But, mainly when choosing the work I intentionally placed concept before form; rational adherence to my brief prevailed over craftsmanship and other aesthetic or stylistic concerns.'[1]

1 Jim Ricks, <http://www.jimricks.info/futureperfect.html>.

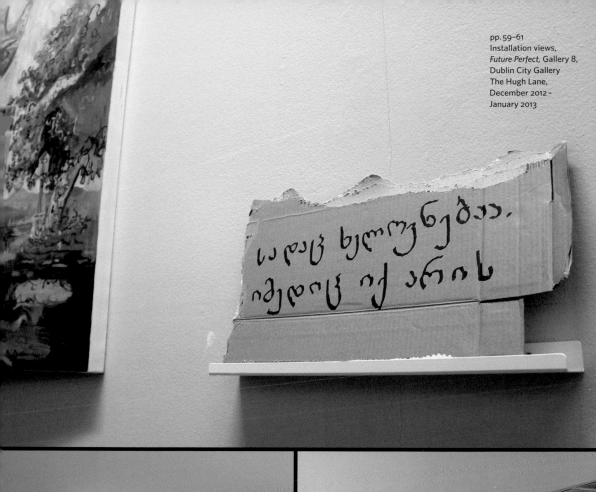

pp. 59–61
Installation views,
Future Perfect, Gallery 8,
Dublin City Gallery
The Hugh Lane,
December 2012 –
January 2013

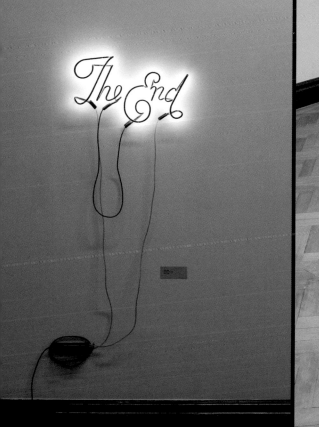

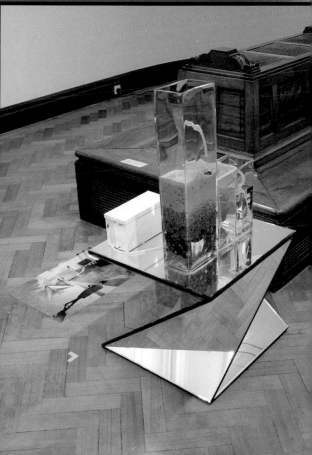

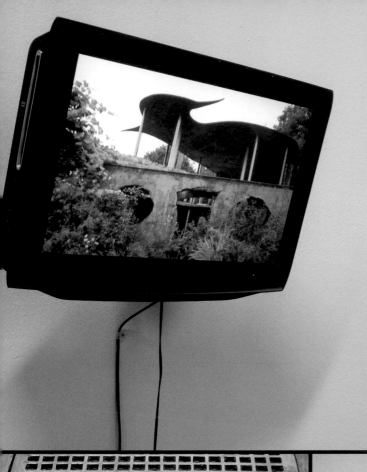

Untitled
Raine-Hexier-Byrne
Bought dice (Feel free to use)

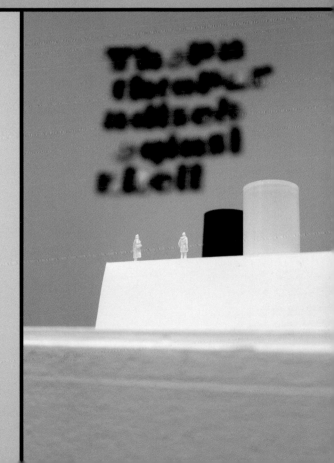

I expect
that my
work
will not be
included
in the
upcoming
exhibition

Safety in numbers (We're OPEN).

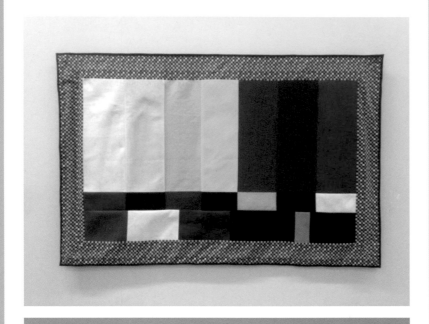

Clodagh Emoe, Sean Lynch,
Gavin Murphy, Linda Quinlan,
Jim Ricks, Lee Welch
Production as Process
Gallery 8, Dublin City Gallery
The Hugh Lane, February 2013

Lee Welch
Test Pattern, 2013
Woven textile
Dimensions variable

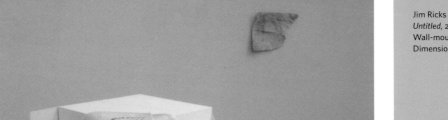

Jim Ricks
Untitled, 2013
Wall-mounted found object
Dimensions variable

Linda Quinlan
Installed by Clodagh Emoe,
Gavin Murphy and Logan Sisley
*Study for 'Under the
Influence of Ananas'*, 2013
Photocopy paper and
wooden plinth
Dimensions variable

Clodagh Emoe
Handmade mat made from
cashmere, moleskin and cotton
17 × 7 m
55 ¾ × 23 ft

The handmade mat was used
in the first enactment of
Mystical Anarchism, 2009.

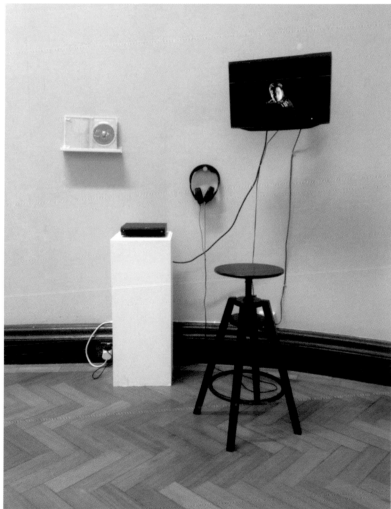

Gavin Murphy
Research materials: Flat screen
television monitor, *Le gai savoir*
(Jean-Luc Godard, 1969)
region 4 DVD; universal DVD
player, headphones; powder-
coated aluminium shelf
(one of three variations on
original design); studio stool
Dimensions variable

I've got a pineapple in my pants and you're all invited.

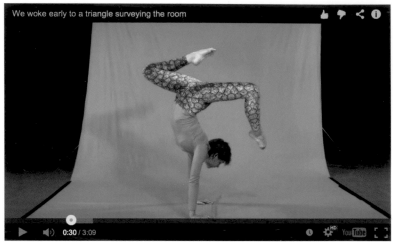

"We woke early to a triangle surveying the room" by Linda Quinlan

Linda Quinlan
We woke early to a triangle surveying the room, 2011
HD video
3 min 9 sec
<http://youtu.be/wnDZGgNFSbc>

by HUGHLANE *on* FEBRUARY 25, 2013 • PERMALINK LEAVE A COMMENT

Posted in JIM RICKS, LINDA QUINLAN

Is there room for dogs in this proposal? We might need a translator!

http://www.youtube.com/watch?v=n1oQF9iQ_9k

by HUGHLANE *on* FEBRUARY 25, 2013 • VIDEO • PERMALINK LEAVE A COMMENT

Posted in LINDA QUINLAN

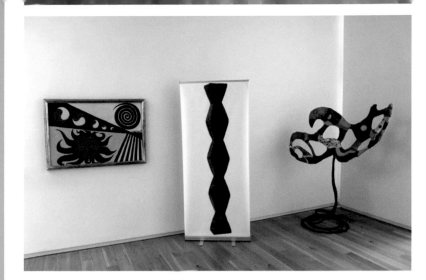

Jim Ricks
*Continuous Endless Column
(Endless Column, Constantin
Brancusi)*, 2013
Digitally printed roll-up banner
and carrying case
Dimensions variable

Image taken by the artist
from the internet archive of
the Museum of Modern Art,
New York, and printed to the
scale of the original sculpture.
Shown as part of *Production as
process* in Dublin City Gallery
The Hugh Lane, May 2013.

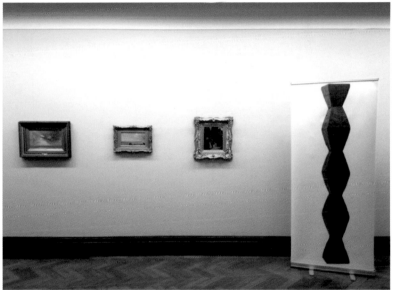

by HUGHLANE *on* MAY 7, 2013 • PERMALINK LEAVE A COMMENT
Posted in JIM RICKS

The soft and the pliable

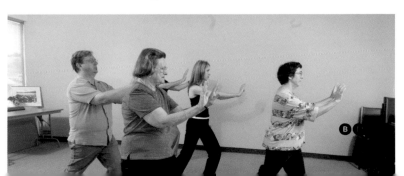

Two exercises in awareness and observation
Lee Welch

10 July – 29 September 2013

Two exercises in awareness and observation took shape through arrangements of objects, printed texts and unwieldy social situations that indexed a larger structure. Planned and unplanned situations allowed unforeseen participation and communication between the artist, art worker and audience. The walls of Gallery 8 were painted with a regular rhythmic pattern of vertical stripes, a measure that played with the parameters of the space, like a concertina that swells and contracts. The repetition of lines induced an order and structure that was interrupted by an arrangement of objects, video and texts.

One interruption was a mirrored shelf supporting six invitation cards along with a collection of objects that changed over the course of the exhibition. A second shelf displayed the six invitation cards propped up against the wall. On one side were a series of texts such as 'Every movement reveals us', while the other side revealed a place and time, coordinates to an event planned within the timeframe of the exhibition, both inside and outside Dublin City Gallery The Hugh Lane. These included weekly tai chi workshops hosted by Natalia Krause in the gallery's Sculpture Hall.

If you can smell garlic, everything is all right was a planned dinner event that failed to materialise and became the epitome of administrative pitfalls encountered. The closing note was the concert, *The Portsmouth Sinfonia (A Homage)*, held in collaboration with the Sundays@Noon concert series. The philosophy of the Portsmouth Sinfonia was that anybody can join and that participating musicians should not be able to play the assigned instrument.

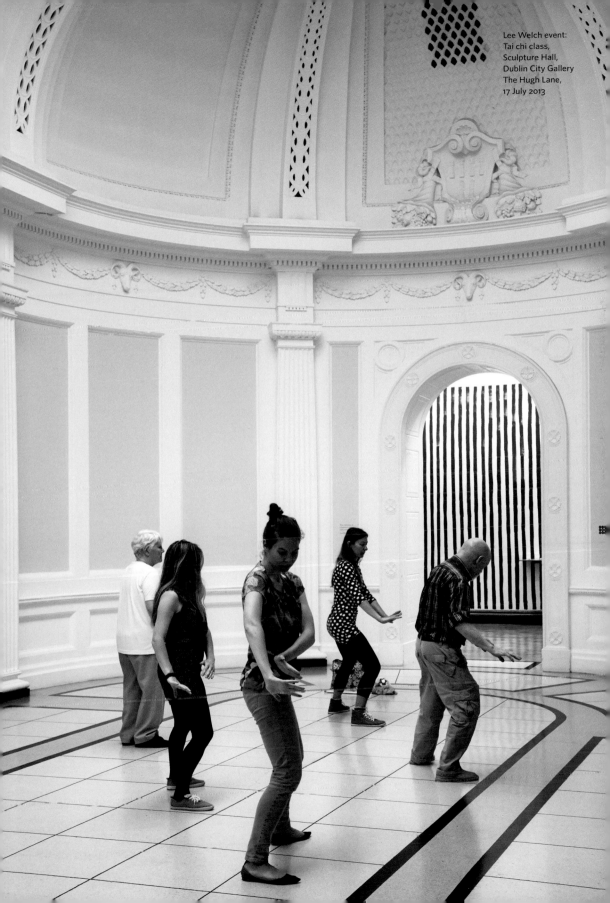

Lee Welch event:
Tai chi class,
Sculpture Hall,
Dublin City Gallery
The Hugh Lane,
17 July 2013

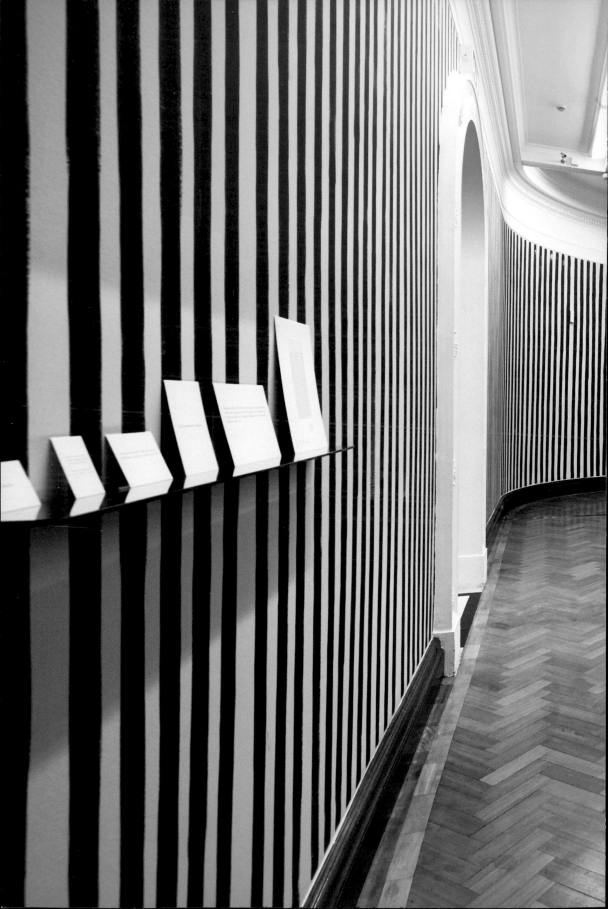

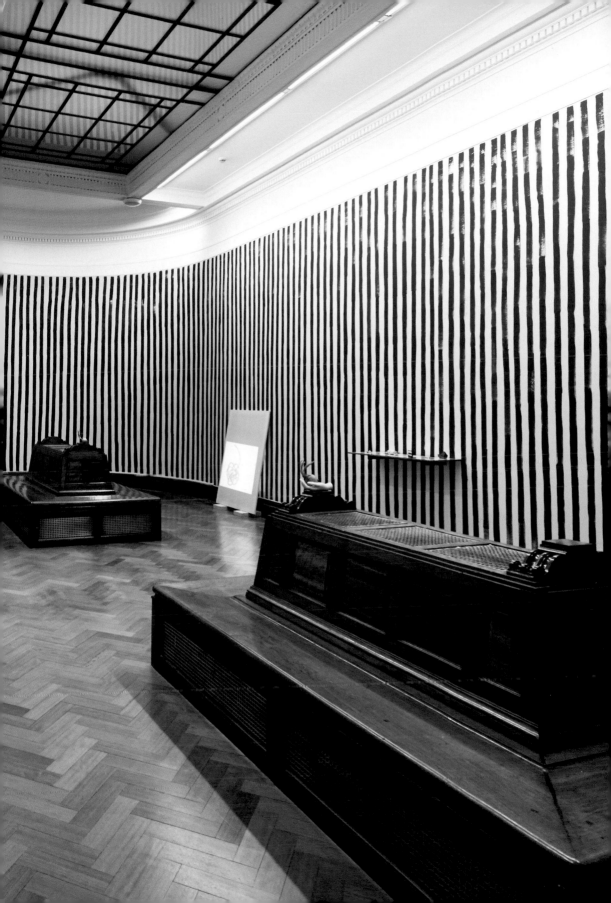

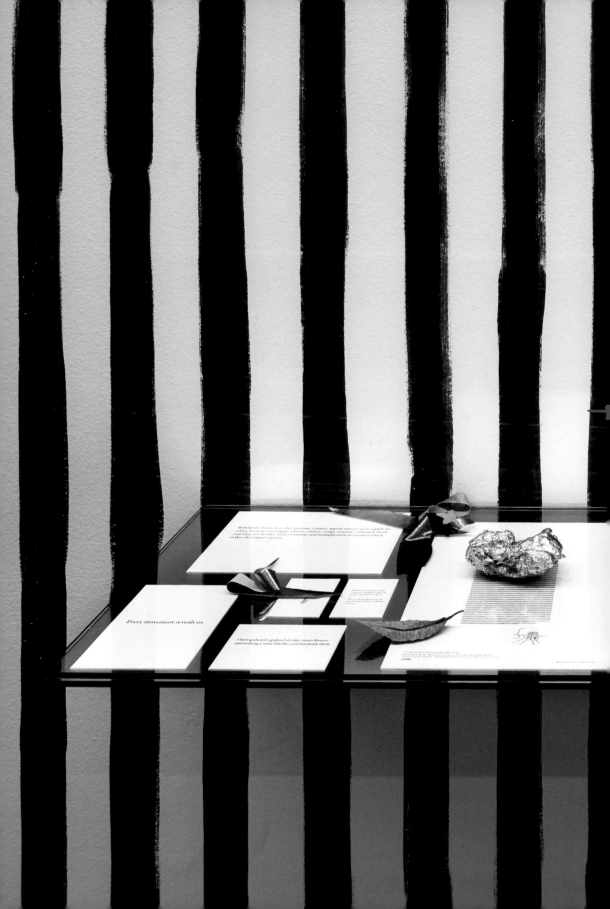

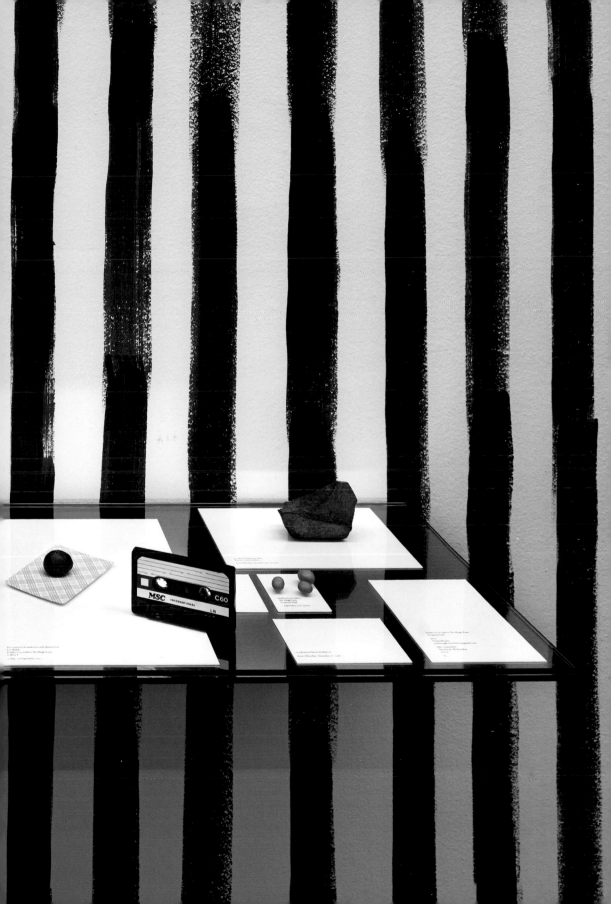

pp. 68–72
Installation views,
Lee Welch, *Two exercises in awareness and observation*,
Gallery 8, Dublin City
Gallery The Hugh Lane,
10 July – 29 September 2013

pp. 74–75
Lee Welch, six invitation
cards (recto), 2013
Lithographic print on card
Dimensions variable
Original layout designed
by Tony Waddingham

'The song was not a production number. That is, it allows little or no action while it is being sung. It lacks a soothing, seducing rhythm; instead it has a certain slow lilt that subtly disturbs the audience instead of lulling it into acceptance. Then, too, there is the melody, which is not easy to catch; it presents too many chromatic pitfalls. Hardly anybody whistles or hums it correctly without the support of a piano or other jj
jj
jj
jj
jj
jj
jj
jj
jj
jj
jj
jj
jj
jj
jj
jj
jj
jj
jj
jj
jj
jj
jj
jj
jj
jj
jj
jj
jj
jj
jj
jj
jj
jj
jj
jj
jj[1] instrument.'[2]

[1] One should always lean backwards whilst typing

[2] Behind the song 'The Man I Love', George Gershwin quoted by Walter Rimler, author of *George Gershwin – An Intimate Portrait*, University of Illinois Press, 2009

[3] **close**

Behold the hands, how they promise, conjure, appeal, menace, pray, supplicate, refuse, beckon, interrogate, admire, confess, cringe, instruct, command, mock and what not besides, with a variation and multiplication of variation which makes the tongue envious.

Que sçais-je?

Whether the events in our life are good or bad greatly depends on the way we perceive them.

or

When I am playing with my cat, how do I know she is not playing with me?

Every movement reveals us.

have gathered a garland of other men's flowers,
nd nothing is mine but the cord that binds them.

CRITICAL ARTISTIC PRACTICES: AN AGONISTIC APPROACH

Chantal Mouffe

The central question that artists aiming at challenging the status quo should ask is the following: how can artistic practices still play a critical role in societies in which every critical gesture is quickly recuperated and neutralised by the dominant powers? There is currently an important debate around this issue and wide disagreement about the answer. On one side, there are those who argue that we are witnessing a 'vaporisation of art' due to an aestheticising of all the forms of our existence. They declare that aesthetics has triumphed in all realms and that the effect of this triumph has been the creation of a hedonistic culture where there is no longer any place for art to provide a truly subversive experience. The blurring of the lines between art and advertising is such that the idea of critical public spaces has lost its meaning, since we are now living in societies where even the public has become privatised.

In a similar vein, some theorists, reflecting on the growth of the global culture industry, claim that the worst nightmares of Theodor Adorno and Max Horkheimer have become true. The production of symbols is now a central goal of capitalism, and through the development of the creative industries, individuals have become totally subjugated to the control of capital. Not only consumers but cultural producers too, are prisoners of the culture industry dominated by the media and entertainments corporations and they have been transformed into passive functions of the capitalist system. Here again the possibility of an effective critique in a range of public spaces seems to have disappeared.

Fortunately this pessimistic diagnostic is not shared by everybody, and other theorists see things in a different way. For instance, we find several who claim that the analysis of Adorno and Horkheimer, based as it is on the Fordist model, no longer provides a useful guide to examine the new forms of production that have become dominant in the current post-Fordist mode of capitalist regulation. They argue that those new forms of production allow for new types of resistance and a revitalisation of the emancipatory project, to which artistic practices can make a decisive contribution.

I would like to intervene in this debate with some reflections about the way to envisage the politics of artistic practices from the agonistic perspective that I have developed in my work. However, I need to clarify at the outset that I do not see the relation between art and politics in terms of two separately constituted

fields, with art on one side and politics on the other, between which a relation would need to be established. There is an aesthetic dimension in the political and there is a political dimension in art. From the point of view of the theory of hegemony that informs my approach, artistic practices play a role in the constitution and maintenance of a given symbolic order – or in its challenging – and this is why they necessarily have a political dimension. The political, for its part, concerns the symbolic ordering of social relations, what Claude Lefort calls the *mise en forme* of human coexistence and this is where its aesthetic dimension lies. This is why I believe that it is not useful to make a distinction between political and non-political art. Instead of speaking of political art, we should rather speak of critical art.

From the agonistic perspective, the enquiry about the possible forms of critical art refers to the way in which artistic practices could contribute to questioning the dominant hegemony. In addressing this question, my starting point is that identities are never pre-given but that they are always the result of processes of identification and that they are discursively constructed. This is why the question to ask concerns the type of identity that critical artistic practices should aim at fostering. To answer this question adequately, we need to grasp the nature of the present conjuncture. Today's capitalism relies increasingly on semiotic techniques in order to create the modes of subjectivation that are necessary for its reproduction. In modern production, the control of the souls (Foucault) plays a strategic role in governing affects and passions. The forms of exploitation characteristic of the times when manual labour was dominant have been replaced by new ones that require the constant creation of new needs and an incessant desire for the acquisition of goods. Hence the crucial role played by advertising in our consumer society. It is in fact the construction of the very identity of the consumer that is at stake in the techniques of advertising. Those techniques are not limited to promoting specific products but aim at producing fantasy worlds with which the consumers of goods will identify. Indeed, nowadays, to buy something is to enter into a specific world, to become part of an imagined community. To maintain its hegemony, the neo-liberal system needs to mobilise people's desires and shape their identities permanently. A counter-hegemonic politics needs to engage with this terrain so as to foster other forms of identification. This is why the cultural domain occupies such a strategic place today. To be sure, the realm of culture has always played an important role in hegemonic politics, but in the time of post-Fordist production this role has become absolutely crucial.

According to the agonistic approach, critical art is art that foments dissensus. It is constituted by a manifold of artistic practices whose objective should be

the transformation of political identities by the creation of new practices and language games that will mobilise affects in a way that allows for the disarticulation of the framework in which current forms of identification are taking place, so as to allow other forms of identification to emerge. Critical artistic practices should contribute to the development of agonistic public spaces where the dominant hegemony would be questioned by giving a voice to all those who are silenced within the framework of the existing hegemony.

I would like to stress that to construct oppositional identities it is not enough simply to foster a process of 'de-identification' or 'de-individualisation'. The second move, the moment of 're-identification', of 're-individualisation', is crucial. To insist only on the first move is in fact to remain trapped in a problematic that sees the negative moment as being sufficient, on its own, to bring about something positive, as if new subjectivities were already there, ready to emerge when the weight of the dominant ideology was lifted. Such a view, which informs many forms of critical art, fails to come to terms with the nature of the hegemonic struggle and the complex process of constructing identities. It is also important not to envisage this struggle as the displacement of a supposedly false consciousness that would reveal the true reality. Such a perspective is completely at odds with the anti-essentialist premises of the theory of hegemony, which rejects the very idea of a 'true consciousness' and asserts that identities are always the result of processes of identification. It is through insertion in a manifold of practices, discourses and language games that specific forms of individualities are constructed. This is why the transformation of political identities cannot consist in a rationalist appeal to the true interest of the subject, but in its insertion in practices that will mobilise its affects towards the disarticulation of the framework in which the process of identification is taking place, thereby opening the way for other forms of identification.

I am convinced that cultural and artistic practices could play an important role in the agonistic struggle because they are a privileged terrain for the mobilisation of affects and the construction of new subjectivities. To revitalise democracy in our post-political societies, what is urgently needed is to foster the multiplication of agonistic public spaces where everything that the dominant consensus tends to obscure and obliterate can be brought to light and challenged. What needs to be relinquished is the idea that to be political requires making a total break with the existing state of affairs in order to create something absolutely new. This is why some people claim that it is no longer possible today for art to play a critical role because it is always recuperated and neutralised. We find a similar problem with those who believe that radicality means transgression and that the more transgressive practices are the more

radical. Then when they realise that there is no transgression that cannot be recuperated, they also conclude that art cannot play a critical political role.

A different mistake consists in envisaging critical art in moralistic terms, seeing its role as one of moral condemnation. Given that we find ourselves nowadays in a condition where any more generally agreed criteria to judge art productions do not exist, there is a marked tendency to replace aesthetic judgments with moral ones, pretending that those moral judgments are also political ones. In my view all those approaches are in fact anti-political because they are unable to grasp the specificity of the hegemonic struggle. To the contrary, according to the hegemonic approach that I have been delineating, it becomes possible to understand the crucial place of the cultural dimension and how artists can play an important role in subverting the dominant hegemony.

'I had rather fashion my mind than furnish it.' — Michel de Montaigne

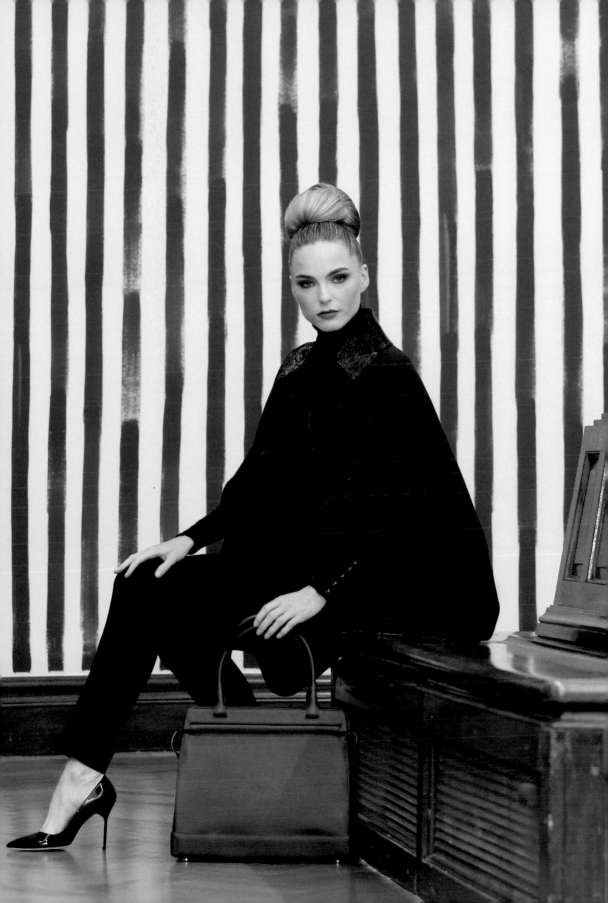

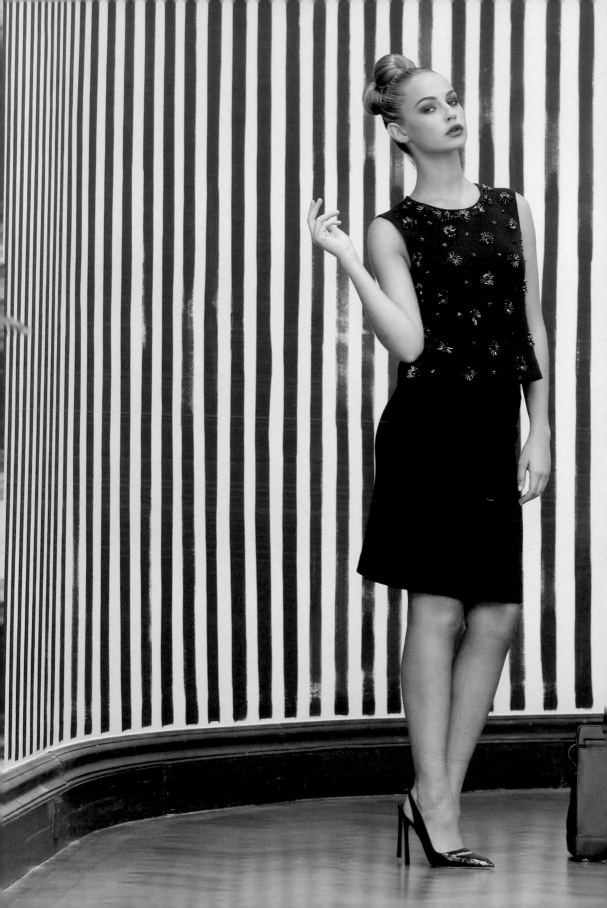

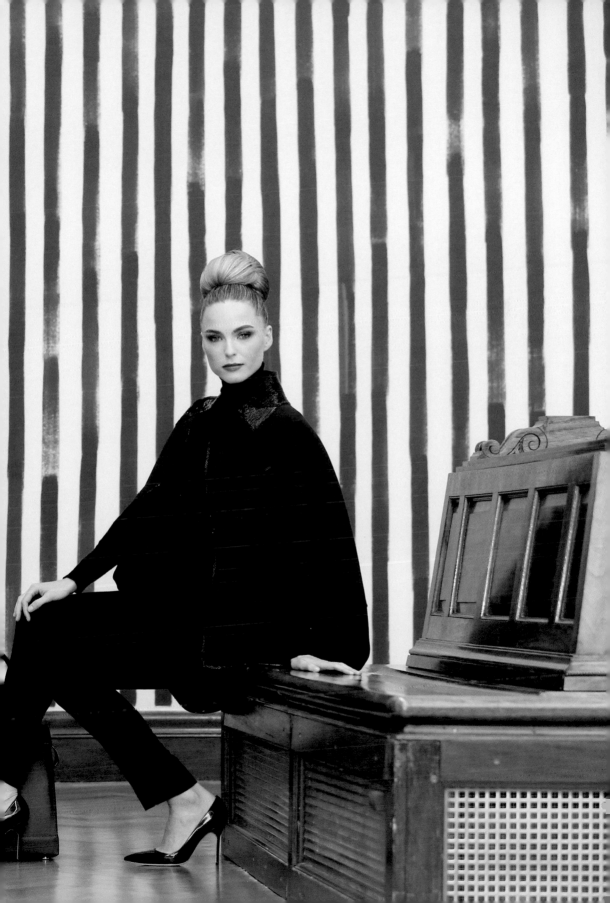

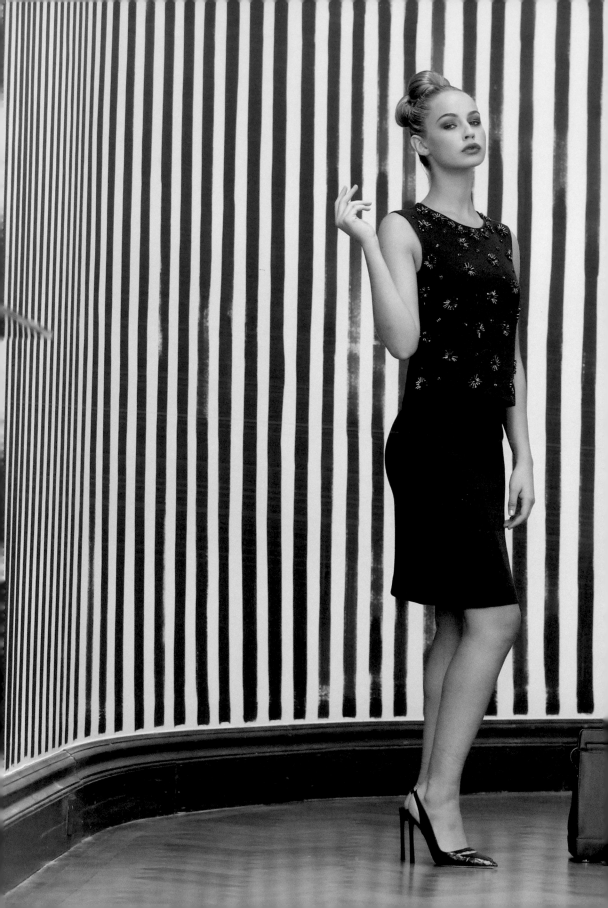

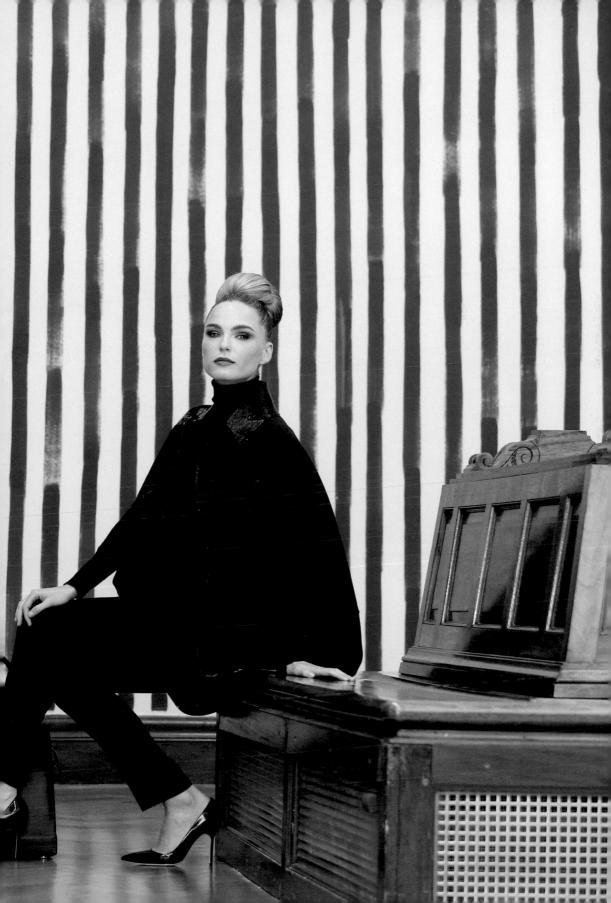

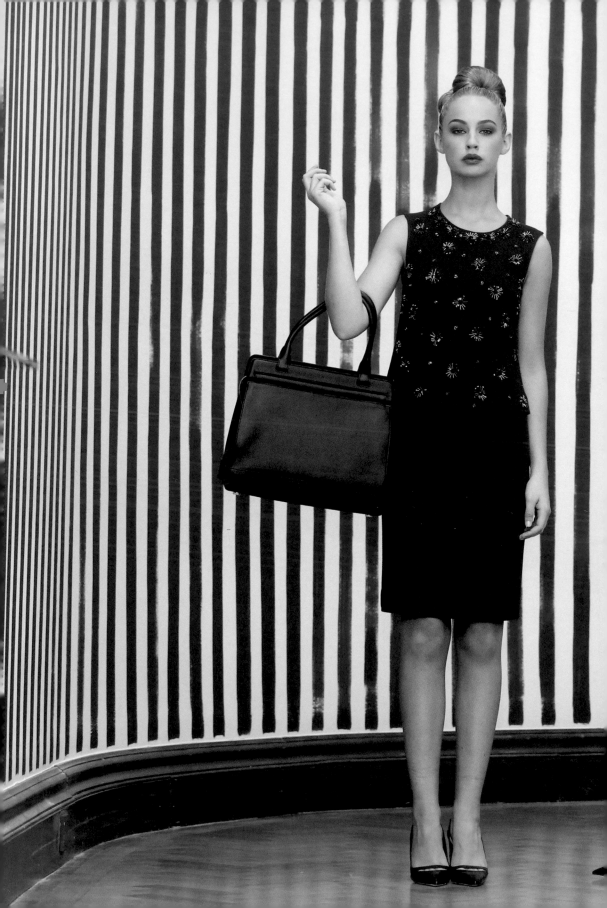

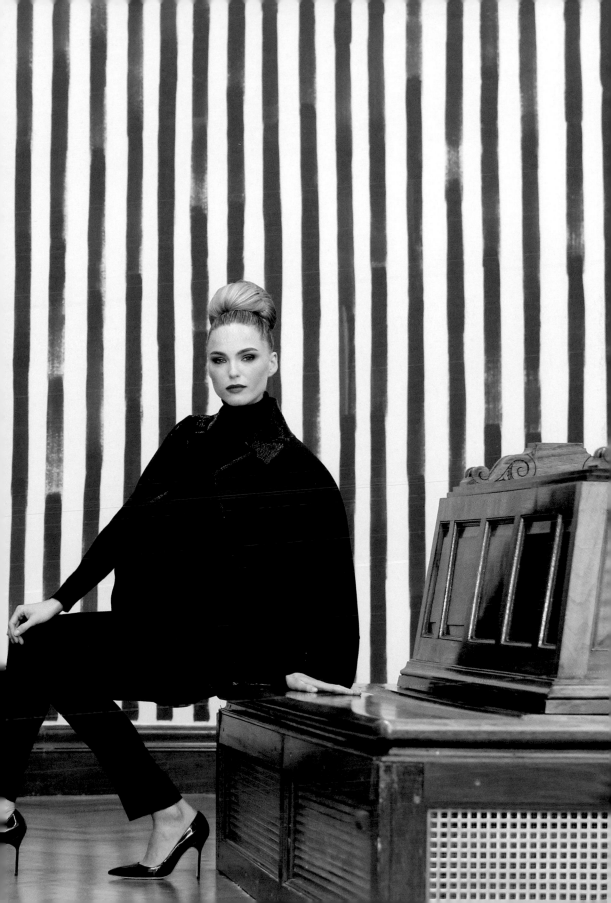

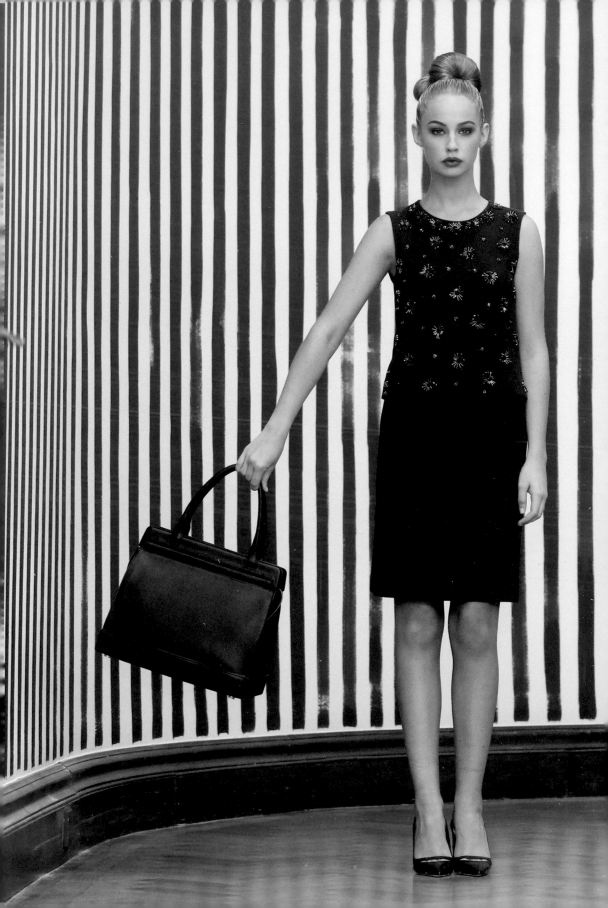

pp. 80–88
Fashion editorial for
Louise Kennedy by
photographer Sasko
Lazarov using Lee
Welch's *Two exercises in
awareness and observation*
as a backdrop.

All clothes and Kennedy
Bag designed by Louise
Kennedy. Models:
Thalia Heffernan,
Morgan The Agency;
Sarah Morrisey, Assets.

p. 90
Photograph by
Lee Welch, 2014

If you can smell garlic,
everything is all right.

by HUGHLANE *on* MAY 23, 2013 • ASIDE • PERMALINK LEAVE A COMMENT

Posted in UNCATEGORIZED

#uncritical #art

┴─┴ ∩ ¯\(ツ)/¯ ∩ ┴─┴ @therealjimricks now
Scarcity is thoughtful. #uncritical #art
Expand ← Reply 🗑 Delete ★ Favorite ••• More

┴─┴ ∩ ¯\(ツ)/¯ ∩ ┴─┴ @therealjimricks 30s
Waste is powerful. #uncritical #art
Expand

┴─┴ ∩ ¯\(ツ)/¯ ∩ ┴─┴ @therealjimricks 44s
Expense is good. #uncritical #art
Expand

by HUGHLANE *on* MAY 21, 2013 • IMAGE • PERMALINK LEAVE A COMMENT

Posted in JIM RICKS

More paintings and sculptures go on show as part of rethink of how permanent collection is displayed

Tate Britain scraps explanatory panels next to works of art

http://www.guardian.co.uk/artanddesign/2013/may/13/tate-britain-scraps-panels-art

This is what democracy looks like

Bookshelf (Hervé Laurent, critique d'art, Genève) (2010), by collectif_factt (Annelore Schneider and Claude Piguet).

Read my lips

When I am playing with my cat, how do I know she is not playing with me?

by HUGHLANE *on* JUNE 14, 2013 • IMAGE • PERMALINK LEAVE A COMMENT
Posted in UNCATEGORIZED

Dusk of Duty................

by HUGHLANE *on* JUNE 12, 2013 • PERMALINK LEAVE A COMMENT
Posted in MICHAEL DEMPSEY
Tagged GALLERY 8, LEE WELCH, SLEEPWALKERS

It is hard to imagine a more stupid or more dangerous way of making decisions than by putting those decisions in the hands of people who pay no price for being wrong.

\- Thomas Sowell

by HUGHLANE *on* JUNE 10, 2013 • IMAGE • PERMALINK LEAVE A COMMENT

Posted in UNCATEGORIZED

Tagged THOMAS SOWELL

Sleepwalking.....

In Dialectic of Enlightenment, Horkheimer and Adorno wrote that life under capitalism was becoming completely administered, taken under control by various agencies,

organizations and institutions.

by HUGHLANE *on* JUNE 6, 2013 • PERMALINK LEAVE A COMMENT

Posted in MICHAEL DEMPSEY

Tagged COMMUNICATION, PRODUCTION, SLEEPWALKERS

A blow-by-blow account of stone carving in Oxford
Sean Lynch

10 July – 29 September 2013

Sean Lynch's installation explored the work of nineteenth-century stone carvers John and James O'Shea, whose naturalistic renditions of animals and plants are still visible in locations in Dublin and Oxford. Popular belief claimed that the O'Sheas had carved a rendition of Darwin's theory of evolution, a contentious subject at the time, in their commission for the new Museum of Natural History, Oxford. Due to a resulting quarrel, a series of impromptu carvings was made by James O'Shea, caricaturing the authorities of Oxford as parrots and owls; these are still visible at the site today.

Lynch's work for *Sleepwalkers* referenced these sites as being alive with diverse allegorical and associative meanings and encouraged a contemporary reappraisal. A focal point of

A blow-by-blow account of stone carving in Oxford was organised in collaboration with Modern Art Oxford, where it was exhibited from 11 April to 8 June 2014. Research and production were supported by Gasworks, London; TrAIN: Research Centre for Transnational Art, Identity and Nation, University of the Arts, London; Cove Park, Scotland; and the Arts Council of Ireland.

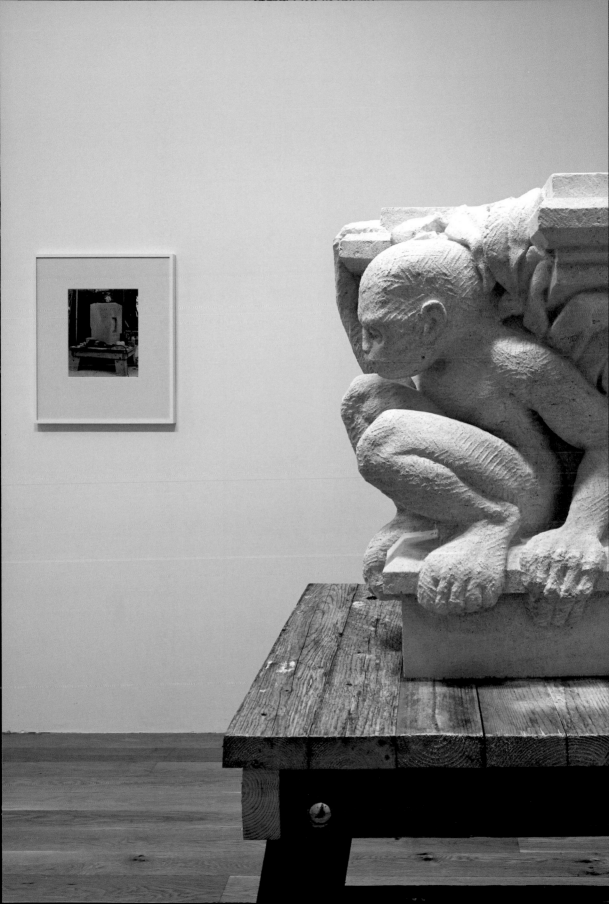

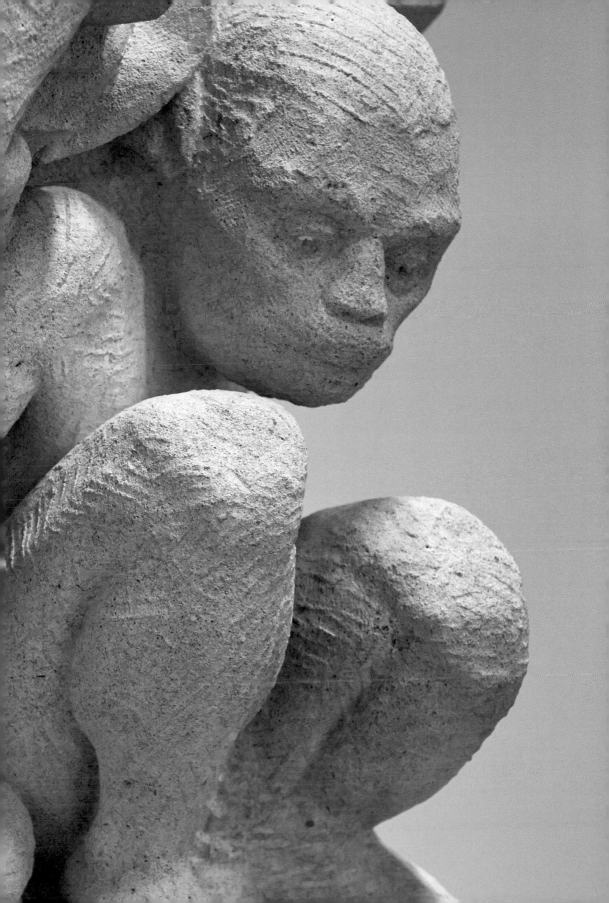

They have mouths,

but they don't speak to us.

They have eyes,

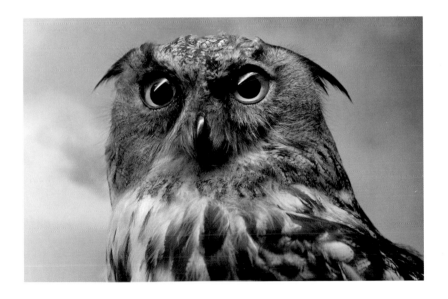

and don't see us.

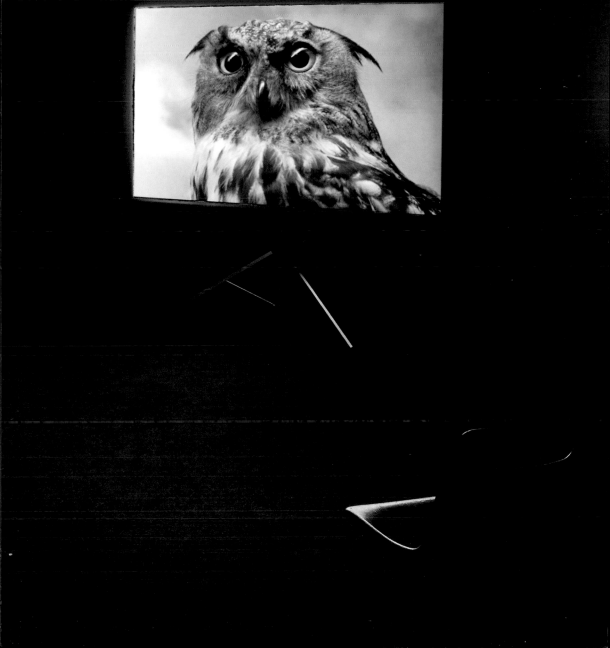

← Francis Bacon Studio
Galleries 1–9

pp. 97–99, 102–04
Installation views,
Sean Lynch, *A blow-by-blow
account of stone carving in
Oxford*, Gallery 10, Dublin City
Gallery The Hugh Lane,
10 July – 29 September 2013

pp. 100–01
Pages designed by Wayne
Daly on behalf of Sean Lynch

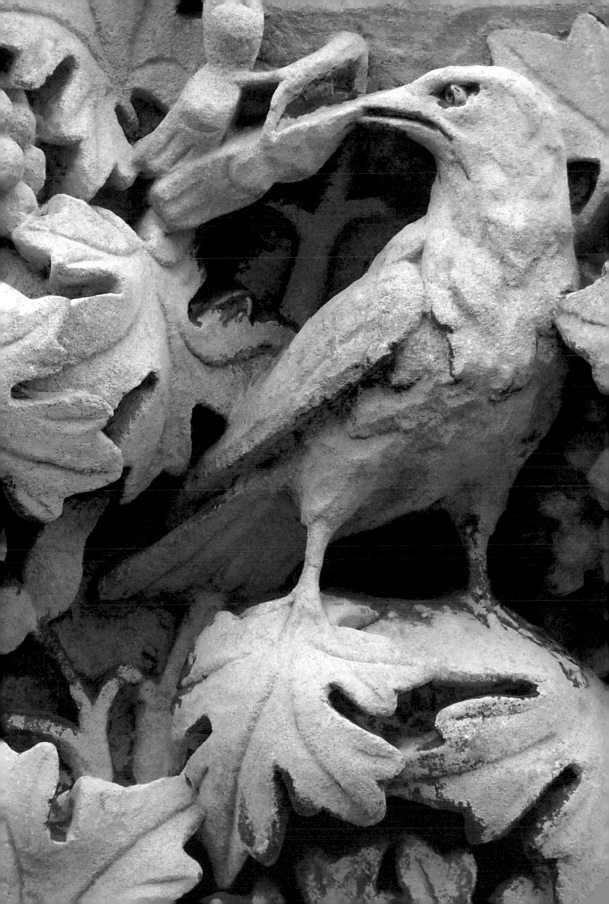

The Wondersmith and His Son
A Tale from the Golden Childhood of the World

Retold by Ella Young, 1927

It was drawing towards night, and the Gubbaun had not given a thought to his sleeping place. All about him was sky, and a country that looked as if the People of the Gods of Dana had been casting shoulder-stones in it since the beginning of time. As far as the Gubbaun's eyes travelled there was nothing but stone; grey stone, silver stone, stone with veins of crystal and amethyst, stone that was purple to blackness; tussocks and mounds of stone; plateaus and crags and jutting peaks of stone; wide, endless, spreading deserts of stone. Like a jagged cloud, far off, a city climbed the horizon. The Gubbaun sat down. He drew a barley cake from his wallet, and some cresses. He ate his fill and stretched himself to sleep.

The pallor of dawn was in the air when a shriek tore the sleep from him. He sat up: great wings beat the sky making darkness above him, and something dropped to the earth within hand-reach. He fingered it – a bag of tools! As he touched them he knew that he had skill to use them though his hands had never hardened under a tool in his life. He slung the wallet on his shoulder and set off towards the town.

As he neared it he was aware of a commotion among the townsfolk – they ran hither and thither; they stared at the sky; they clung together in groups. 'What has happened to your town?' said the Gubbaun to a man he met. 'A great misfortune has happened,' said the man. 'This town, as you can see, has the noblest buildings in the world: poets have made songs about this town. This town is itself a song, a boast, a splendour, a cry of astonishment!

'Three Master Builders came to this town – builders that had not their fellows on the ridge of the world. They set themselves to the making of a Marvel; a Wonder of Wonders; a Cause of Astonishment and Envy; a Jewel; a Masterpiece in this town of Masterpieces – this place that is jewelled like the Tree of Heaven and drunken with Marvels!

'One pact alone, one obligation they bound with oath on the townsfolk – no living person was to come within the enclosure where they worked; no living person – man, woman, or child – was to set eyes on them when they passed through the town with the tools of their trade in their hands. It was Geas for them to be looked on. We cloaked our eyes when they passed, we darkened our windows when they passed, we closed our doors.

'Three days they were working and passing through the town with the tools of their trade. We had contentment, and luck and prosperity, till the whitening of this dawn. Then a red-polled woman thrust her head forth – my curse on the breed and seed of her for seven generations – she set the edge of her eyes on the three Master Builders. They let a screech out of them and rose in the air. They put the shapes of birds on themselves and flew away – my grief, three black crows! Now the stone waits for the hammer: and the hammer is lost with the hand that held it!'

The Gubbaun tightened his grasp on the wallet, and his feet took him of their own accord away from the town. 'The tools have come to the man who can handle them,' said the Gubbaun to himself, 'but I'll handle them for the first time where there are fewer tongues to wag.'

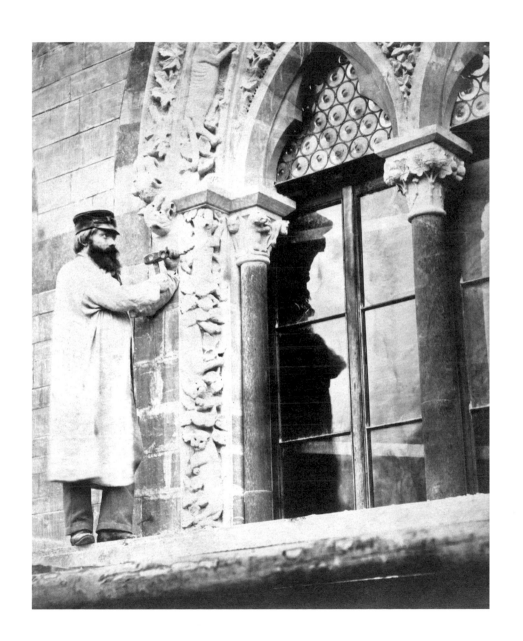

Walking at his will, he came to a place where a great chief's dune was a-building. The folk that fashioned it were disputing and arguing among themselves.

'It is right,' said one who had an air of authority and a red cloak on him, 'it is right that on this lintel there should be an emblem to show the power of the dune — an emblem to put loosening of joints and terrors upon evil-doers.'

'It is more fitting,' said another, 'that the man who carves the emblem should be honoured in it.'

'Nay,' said a third, 'that the man who raised the stone should be honoured in it. I myself should be honoured.' So the clash of tongues and opinions went on.

'The blessing of the sun, and the colours of the day to you,' said the Gubbaun. 'Have you work for a Craftsman?'

'What Craftsman are you?' said they, 'that come hither a-begging? The world runs after the Master Craftsman — we have no need of bunglers!'

'I am a Master Craftsman.'

'Hear him!' cried they all. 'Where are your apprentices? What dunes have you built? What jewels have you carved? Tell us that!'

'A man with ill-cobbled brogues, and burrs in his coat — a likely lie!'

'Put me to the proof,' said the Gubbaun, 'set me a task!'

'So vagrants talk,' said the man in the red cloak, 'while good men sweat at labour. Have you the hands of a mason?'

'What need to waste wit and words on this churl?' cried another.

'It is time now to stretch our limbs in the sun, and to eat. Let us go to the stream where the cresses are.'

They went.

When they were well out of the way, the Gubbaun took his tools. He worked with a will. The work was finished when they straggled back.

The first that caught sight of it cried out: the cry ran from man to man of them. There was hand-clapping and amazement. The Gubbaun had carved the King-Cat of Keshcorran — more terrible than a tiger! The Cat crouched midway in the lintel, and on either side of him spread a tail, a tail worthy that Royal One! Bristling with fierceness it spread; it slid along on either side, with insinuating grace and with infinite cunning, losing itself at the last in loops, and twists, and foliations and intricacies that spread and returned and established themselves in a mysterious, magical, spell-knotted forest of emblems behind the flat-eared threatening head.

'There is an emblem for the Builder in that,' said the Gubbaun, 'and an emblem for the Carver, and an emblem for the Man who planned the Dune, and for the Earth that gave the stone for it. Is it enough?'

'It is enough, O Master Craftsman, our Choice you are! Our treasure! Stay with us. The chief seat in our assembly shall be yours. The chief voice in our council shall be yours. Stay with us, Royal Craftsman.'

'I have the wisdom of running water and growing grass,' said the Gubbaun, 'and my feet must carry me further — still water is stagnant! May every day bring laughter to your mouths and skill to your fingers; may the cloaks of night bring wisdom.'

He left them.

Often he was wandering after that when the sun was proud in the sky — and often drank honey-mead in Faery-Mounds. He saw the Mountain-Sprites dancing.

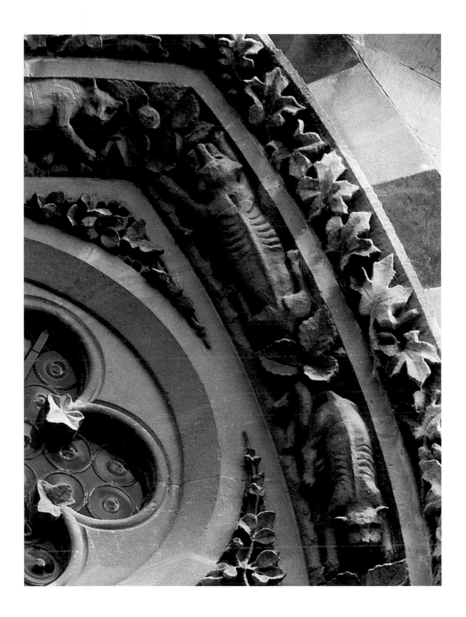

The King-Cat of Keshcorran? In Irish myth the King-Cat was one of a group of grotesque animals to be found at caves in County Roscommon and Sligo, each reputed to be 'The Hellmouth Door of Ireland'. Perhaps O'Shea remembered the story of the Gubbaun and asserted to bring forth evil monstrous cats to the facade of the museum?

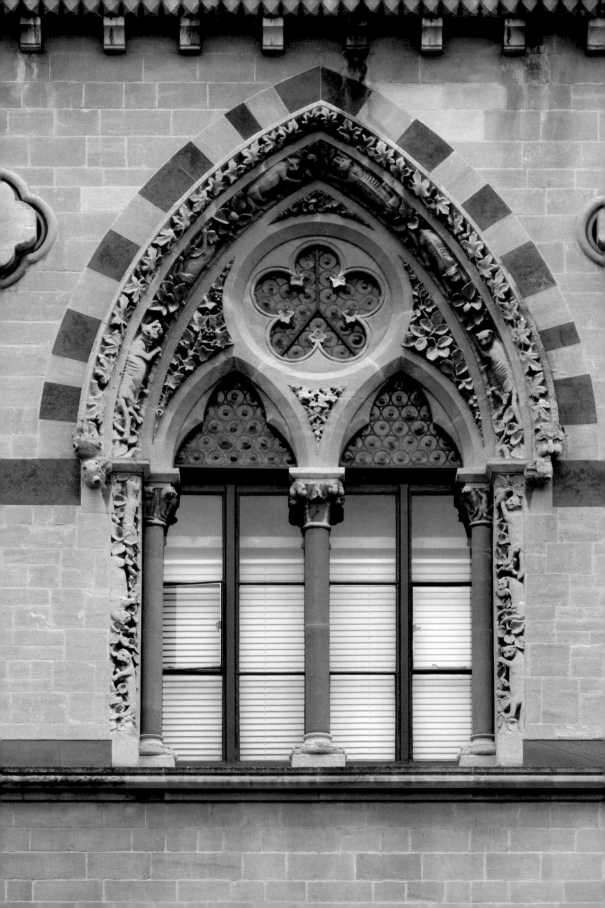

pp. 107–14
Text and page layout by
Sean Lynch

First published in Ella
Young, *The Wondersmith
and His Son*, Longmans,
Green & Company,
New York, NY, 1927.

p. 107
James and John O'Shea,
detail of carving at Trinity
College Dublin, c. 1856

p. 109
James O'Shea, Oxford, 1859

pp. 110–11
Photographs detailing
various stages of a
stonecarving by Stephen
Burke, 2013

pp. 113–14
James O'Shea, The Cat
Window at the Oxford
University Museum
of Natural History, 1859

Bubble Wrap Game: Hugh Lane
Jim Ricks

31 October 2013 – 19 January 2014

Jim Ricks's installation for *Sleepwalkers* developed a string of competing 'yardsticks' in a humorous and diverse display of objects – it included paintings from The Hugh Lane's collection, borrowed artworks from private collections and kitsch objects from flea markets.

They were all exhibited on an equal level as an open fragment rather than a closed system. The trail of objects had no fixed starting point and could be read in either direction. This created a loop that Ricks, citing Karl Marx, sees as historical narrative repeating 'first as tragedy and then as farce'.

Viewers were also invited to create their own narratives and connections between the objects on display. Ricks called this method 'Synchromaterialism'. For his *Sleepwalkers* installation, Ricks included works from The Hugh Lane's collection by artists such as Gerard Dillon and Robert Ballagh, as well as works on loan from artists including Raphael Zarka and James Hanley.

Ricks's work challenges our perceived notions of ownership and authorship. By expanding acceptable thinking about curatorial practice, he dissolved normally accepted hierarchies. His belief in changeable standards and their contradictions to life was an undercurrent in the installation. In *Bubble Wrap Game: Hugh Lane*, Ricks shifted from biography and medium to method and situation, and reviewed ideas about the symbolic and monetary value of property.

Artwork
temporarily
removed

Artwork
temporarily
removed

Artwork
temporarily
removed

Artwork
temporarily
removed

Artwork
temporarily
removed

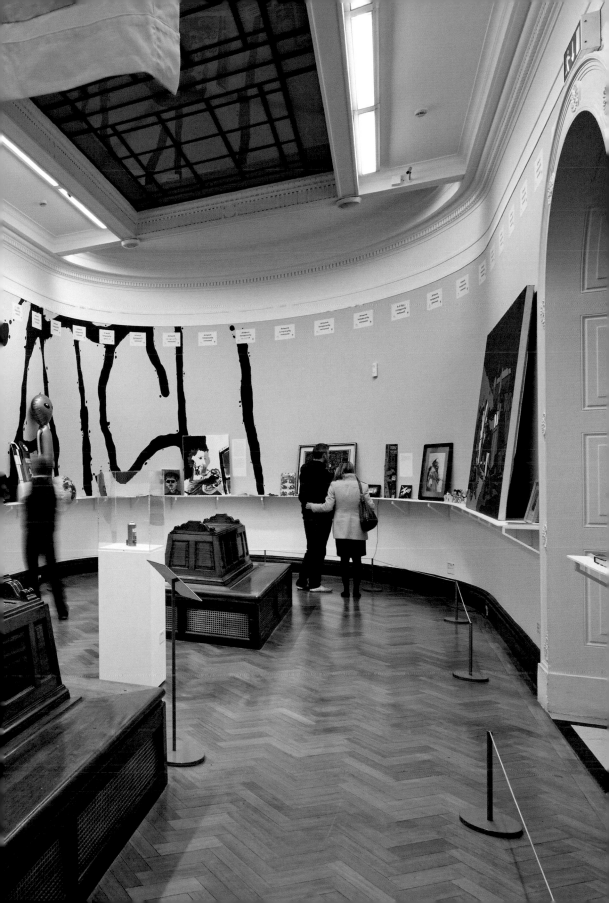

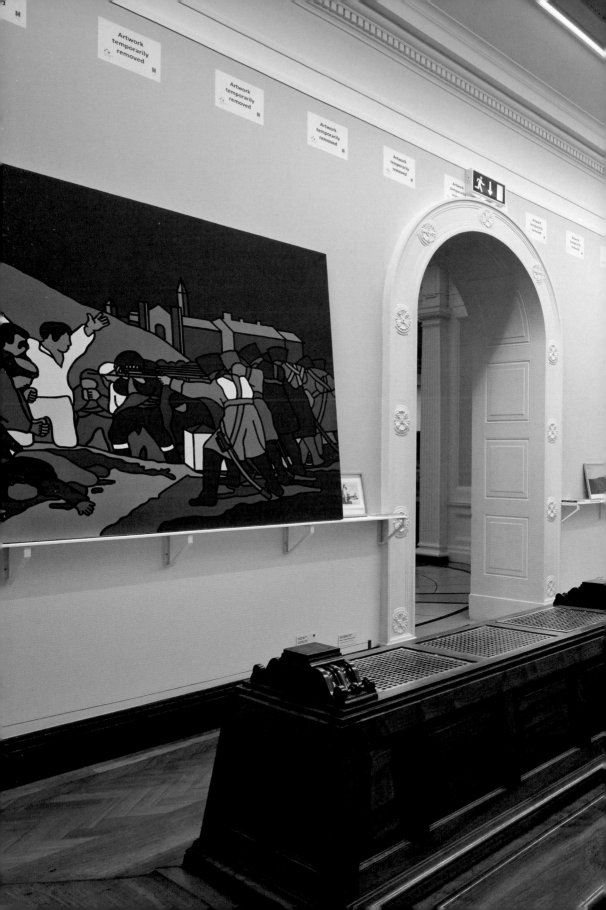

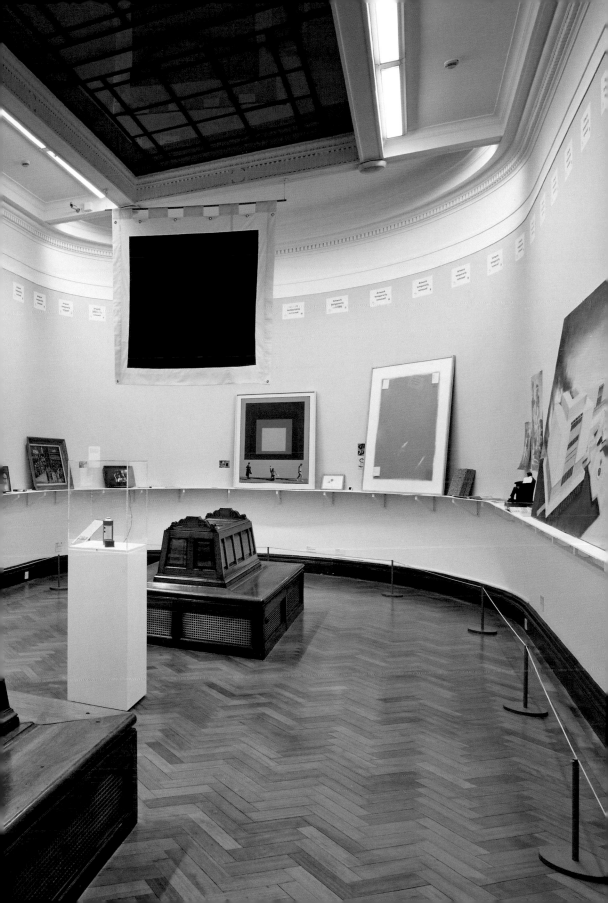

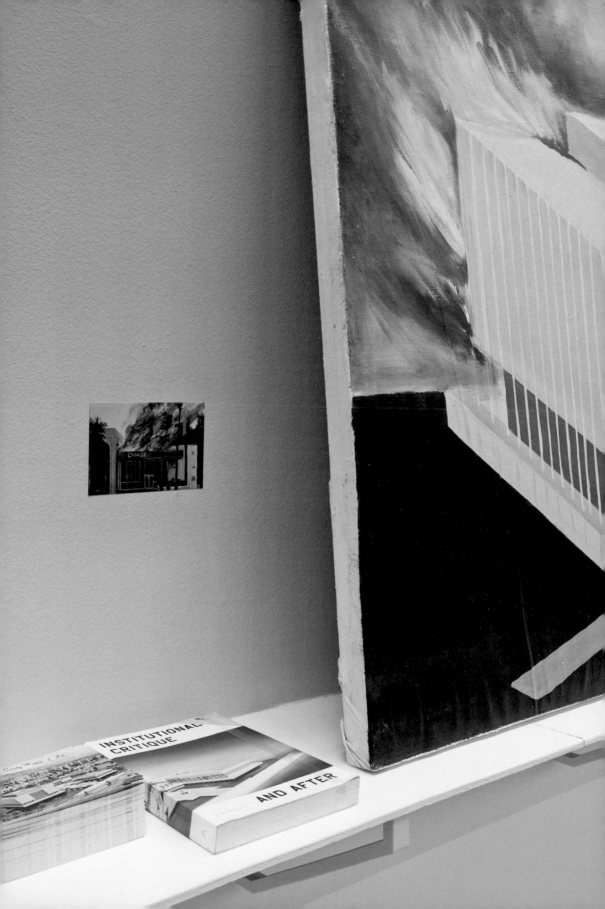

RE: Loan of Ruscha

 30 November 2012 15:39

To: "jimricks@gmail.com" <jimricks@gmail.com>

Dear Mr. Ricks,

██
███████████████████████████

As far as procedures for requesting loans, please see the attached Loans Policy. It should provide all the
details you need to submit a loan request. ███
████████

Unfortunately, the large oil painting (72.252) is unavailable for loan due to conflicting exhibition dates. It
is slated to be part of our upcoming exhibition "Damage Control: Art and Destruction Since 1950" which
will open at the Hirshhorn in October 2013 and is expected to tour through Oct 2014.

Don't hesitate to contact me with any further questions.

All the best,

████████

████████████

████████████████

Hirshhorn Museum and Sculpture Garden

Smithsonian Institution

P.O. Box 37012, MRC 356

Washington, DC 20013-7012

Jim Ricks takes a trip to the local 'pinter' shop in Kabul to commission a reproduction of Ed Ruscha's *The Los Angeles County Museum on Fire* (1965–68)

[Kabul. Street sounds.
Cut to inside 'pinter' shop]

It's the …
Museum.
… museum in Los Angeles.
The museum in Los Angeles.

Did they burn it?
No, no. It's a famous painting.
What is this fire?
It is the … the artist was
making a joke.

[Outside car horn sounds for several seconds]

Shall we do something caught on fire also here, or not on fire? Yes, the whole … exactly.

[Discussion in Dari]
Oh.
Oh.

This is fire.
And the smoke is here.

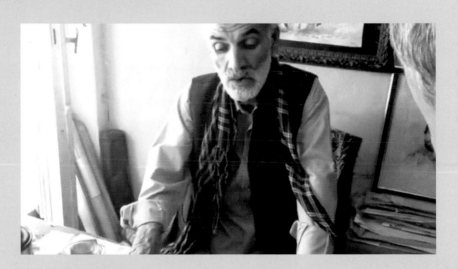

Similar.

[Measuring to get scale of painting]

This is for…

[Counting money]

Five thousand.
This is five thousand.

I told them: 'keep my dignity safe'.
Because I brought all these people here.
[Laughter]

[Sound of rubber stamp]

[Slap]

[Very firm handshake]

Thank you very much.

Several weeks later the 'pinter' Najeebullah Najeeb
finishes his copy of the Ed Rusha painting

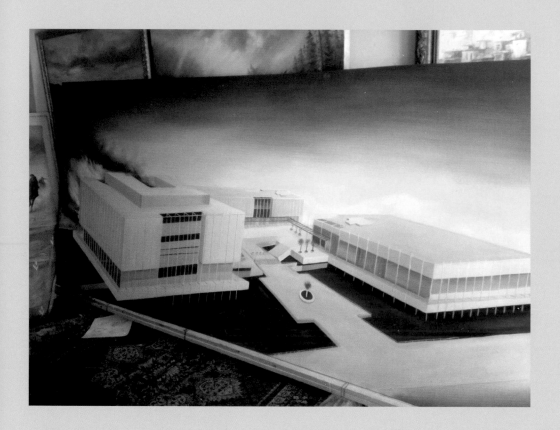

Baharistan Honer Painting

Date / / 1390 Najeebullah "Najeeb"

قیمت	تعداد	اسم جنس	شماره

E-mail:Najeeb.Najeeb58@yahoo.com
Mob:0799318132

133

Everything must go now

1 pm — 4 pm, 18 January 2014

For the closing event for *Bubble Wrap Game: Hugh Lane* Jim Ricks curated a range of artists and practices that could not normally be shown in an ordinary exhibition. Pádraic E. Moore created a soundtrack for the final hours of the exhibition using vinyl records and a set of turntables. Chef Kevin Powell, founder of Guerrilla Gruel, produced a reduced, minimal six-course banquet which was available to the public and served on a correspondingly minimal 'long table' created to bisect the elegance of the Sculpture Hall. Ricks exhibited *Painting Is Dyed*, a large new textile piece derived from a Sean Scully painting from The Hugh Lane collection. David Eager Maher selected two historic works by eighteenth-century artist James Barry to counter. In his response, Eager Maher pays close formal and stylistic attention to his precursor, but semiotically updates the works found in The Hugh Lane collection. The day ended with a closing reception for this spin-off exhibition, *Savage State*.

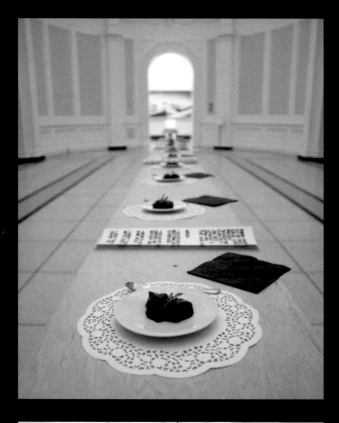

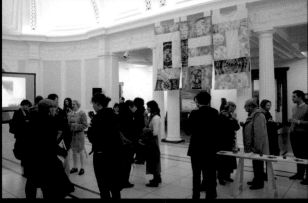

Play it again Sam!

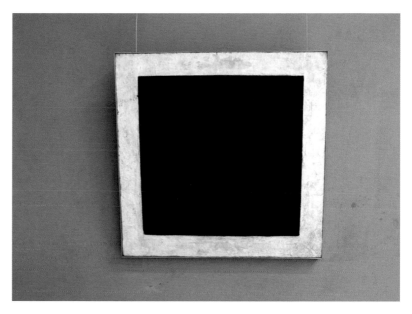

"Life knows what it is doing, and if it is striving to destroy, one must not interfere, since by hindering we are blocking the path to a new conception of life that is born within us. In burning a corpse we obtain one gram of powder: accordingly, thousands of graveyards could be accommodated on a single chemist's shelf. We can make a concession to conservatives by offering that they burn all past epochs, since they are dead, and set up one pharmacy".

"On the Museum," Kazimir Malevich 1919

ALL POSTS FOR THE MONTH **FEBRUARY, 2014**

Detail from the 'Banchittino'

Some distance

by HUGHLANE *on* FEBRUARY 8, 2014 • IMAGE • PERMALINK LEAVE A COMMENT

ALL POSTS FOR THE MONTH **MARCH, 2014**

Ooopsie!

Found in the basement.

SAME BUT DIFFERENT

Marysia Wieckiewicz-Carroll

Sleepwalkers. Production as Process, a year-long project played out within the period walls of Gallery 8 at Dublin City Gallery The Hugh Lane, was conceived as a site for experimentation, 'where one's non-specific expectations of museums can be stretched out'. This 'one', this vessel that projects the said expectations, is not defined; it is an open invitation, reaching out to practitioners, cultural producers and also the audience, and summoning them to help in the quest to analyse or test out the contemporary understanding of the museum and its role.

The discourse surrounding the relevance of museums today is not new, but has been gradually gaining urgency in capitalist reality. In recent years (and I am aware of the risk of running into hasty generalisations), the rise of bienni-als, art fairs and private museums has caused a significant shift in the way we encounter art and, as a result, challenged the existing conditions of staging such encounters in public institutions.[1] According to Charles Esche: '[Art] has become an active space rather than one of passive observation. Therefore the institutions to foster it have to be part community centre, part laboratory and part academy, with less need for the established showroom function.'[2] In order to stay attuned to public needs and attract footfall, museums have been dis-couraged from acting as a mere 'repository' and, faced with growing financial pressures, coerced into a self-critical mode calling for a revalorisation of their parameters and institutional objectives. Translated into practice, this often means mimicking the operational models of arts centres, agencies seen as less fossilised but at the same time collection-less and, as such, carrying different sets of responsibilities towards their audiences. Taking into account the histori-cal legacy of a museum, its remit and accountability for the collection, the vital question emerges: does it need to continuously reinvent and think itself anew?

In March 2013, during the fourth *Former West* congress – a project exploring the space of art and global politics in the context of the post-1989 Europe – art theorist and curator Irit Rogoff presented a tentative set of ideas and reflections focused around the theme of infrastructure, at first glance, a subject somewhat disconnected from art production.[3] Developed in collaboration with a group of colleagues under the umbrella of 'Freethought', it was put forward as a speculative beginning of a discussion proposing to engage critically with the notion of infrastructure. 'Why infrastructure?' – asked Rogoff, 'Why a term

In his seminal paper Okwui Enwezor argues against the type of speculative and generalist commentaries that 'equate the task of an exhibition with entertainment, fashion, new thrills and discoveries'.
See, 'The Postcolonial Constellation: Contemporary Art in a State of Permanent Transition', Research in African Literatures, Vol.34, No.4, Winter 2003, pp.57–82.
Charles Esche, 'What's the Point of Art Centres Anyway? – Possibility, Art and Democratic Deviance', Republicart.net, 2004, <http://republicart.net/disc/institution/esche01_en.htm>.
For further information on *Former West* and Irit Rogoff's keynote, see <http://formerwest.org>.

so unloved and so unlovely?' Indeed, it proves difficult to romanticise this utterly pragmatic phenomenon associated mainly with technocratic efficiency. Described by Rogoff as a set of protocols, platforms and rules, it signifies a supporting and interconnecting system that, in short, facilitates the production and distribution of goods and services. Think 'infrastructure' and what springs to mind is roads, traffic, transportation or water supply, in other words the means of successfully moving things from one place to another. Thus defined, infrastructure operates as an enabling mechanism that allows for an effective 'technical, organisational and support delivery'.

As Rogoff promptly observed, infrastructure focuses on *making something possible* and it is this 'enabling' component that fills it with critical potential. The over-reliance on infrastructure and the automatic replication of its protocols can lead to stagnation and can, in turn, be restrictive. By heavily depending on schematics, we eradicate a possibility for change. Rogoff proposed that by recasting our understanding of infrastructure and its use, we can unearth a set of hidden potentialities, which instead of reproducing knowledge allow for its reframing in a novel context. Therefore we need to think of new modes for 're-occupying' the existing infrastructure so as not to reproduce the status quo but to 'reframe questions', 'rethink the very notion of platforms and protocols, to put in proportion the elevation of individual creativity, to further the shift from representation to investigation'. This, she suggests, can be achieved by turning the focus away from efficiency towards incoherence – an introduction of elements of insubordination and friction into the existing system. Gilles Deleuze and Félix Guattari framed these moments of disruption and disobedience as asygnifying ruptures that create a potential for disconnecting from present configurations and an emergence of new meanings.

Former West itself can be seen as a very apt and radical example of critical application and a recasting of existing models of institutional infrastructure. Conceptualised as 'a long-term international research, education, publishing and exhibition project', it operates without a fixed abode, always shifting location and appropriating the structures of existing educational and museum institutions to enable its performance. Responding to site-specific historical memory and the potential of a given space, *Former West* simultaneously merges these with materials and knowledge acquired during its previous stagings, thus creating an overlapping pattern of territories and re-aligned connections that introduce imbalance into the existing structures of a hosting institution. During each of its iterations, the congress engages in an extensive process of research, knowledge and art production whose outcomes are chronicled and posited on its digital platform. As such, *Former West* constitutes an unusual

living hybrid – a museum without walls, a thought repository that stretches beyond the known and well-established modes of institutional infrastructure, exhibition-making and exchange of knowledge.

But how can we link the concept of infrastructure and asignifying ruptures to address the status of a contemporary museum? Annie Fletcher, Curator of Exhibitions at one of the most progressive institutions, Van Abbemuseum in Eindhoven, often revisits this quote from Walter Benjamin's 'On the Concept of History' (1940): 'In every epoch, the attempt must be made to deliver tradition anew from the conformism which is on the point of overwhelming it'. Undeniably, publicly funded institutions like The Hugh Lane operate within a complex infrastructure, which facilitates the delivery of its programme. They are bound by a set of technical protocols, health and safety regulations, financial restrictions and their explicit and implicit duties towards stakeholders. Above all, they need continuously to redress their role in preserving their permanent collection. With regard to this, in the context of museums, the concept of asygnifying ruptures should not be seen as shorthand for a breaking with tradition and the dismissal of that responsibility. Instead, it should be cast as an opportunity to break connections with conformism. In other words, a museum should not rely solely on conventional methods of display and distribution through rotating their repertory, but also seek new and radical modes of engaging with its archive in order to produce new connections and knowledge.[4]

For a long time, 'artists have been the real catalyst for institutional innovation;' they can inject incoherence into the operational infrastructure of a cultural institution.[5] In this case, they can and do employ unorthodox methods of engaging with a museum collection as a means of artistic investigation as opposed to mere representation. Indeed, they experiment with standard institutional operations in order to stretch them as far beyond their limits as possible. *Sleepwalkers. Production as Process* was exactly this – a space for playing out frictions within the existing model of exhibition-making and the operational structure of an institution. It created tensions and a need for constant renegotiation of roles and competences; a room where artists became curators, collaborators and registrars, who in the process of their investigation unearthed forgotten objects and untold histories, staged interventions and interrupted the existing programme with makeshift exhibitions. Some of these actions unfolded beyond the comfort zone of established operational procedures. Throughout, The Hugh Lane as a means of delivery remained the same, but *what* it delivered exposed our own limitations as art producers and viewers and gave us a glimpse of possibilities produced by the injection of incoherence, if only we allow it in.

For further information on curating the collection and the role of museum today, see Annie Fletcher, 'Where is the next generation of curators who work with collections', 2012, <http://vimeo.com/43100352>. Daniel Birnbaum and Hans Ulrich Obrist, 'Museum on The Move', *Artforum*, Summer 2010, p.301.

In Art We Are Poor Citizens
Gavin Murphy

20 February – 25 May 2014

Gavin Murphy's exhibition *Remember* in 2010, part
of the *Golden Bough* series (2008–11) at The Hugh
Lane, used critical and historical documents,
collected fragments of texts pertaining to the
ruin, art and literature, the museum, the novel,
and the seen and unseen fabric of Charlemont
House (the site of The Hugh Lane). Through audio
and images, the installation considered the arts
as a system for connecting knowledge, ideas and
cultural memory.

For the *Sleepwalkers* series, Murphy continued
his engagement with the history of The Hugh
Lane, focusing on its collection, its acquisitions
and its exhibitions. He also measured the changing
role of the museum in contemporary society.
Murphy was given the opportunity to revisit
and engage in a self-reflexive dialogue with the
gallery's past and present, working with The Hugh
Lane's collection and its archive through a series
of interconnecting 'texts'. Within the context of
museological discourse and its pedagogic role,
Murphy remembered the forgotten histories
of The Hugh Lane as a municipal museum, as a
space for defining, contesting and interrogating
nationalism and our perceived cultural identities.

LANE BEQUEST.

INGRES

104. Portrait of VINCENT LÉON PALLIÈRE by J.A.D.INGRES.

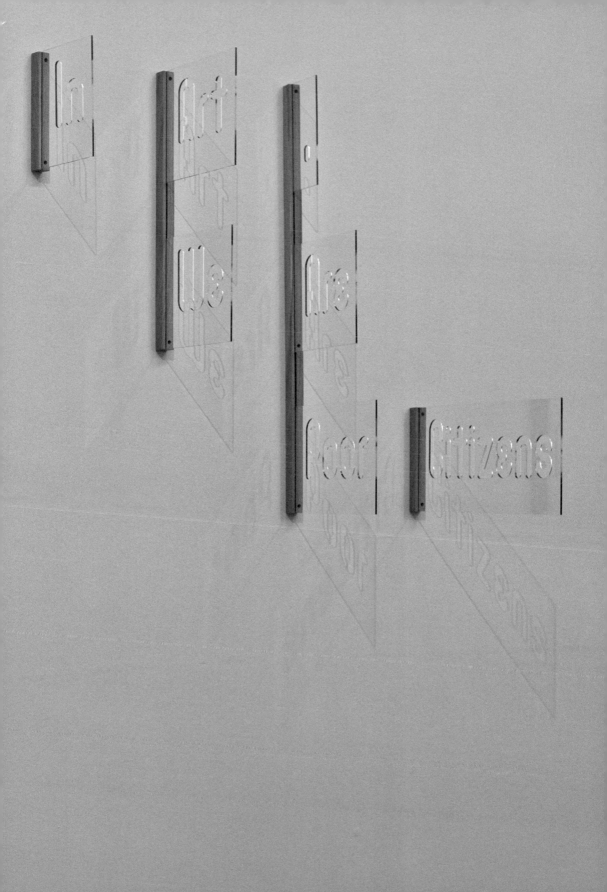

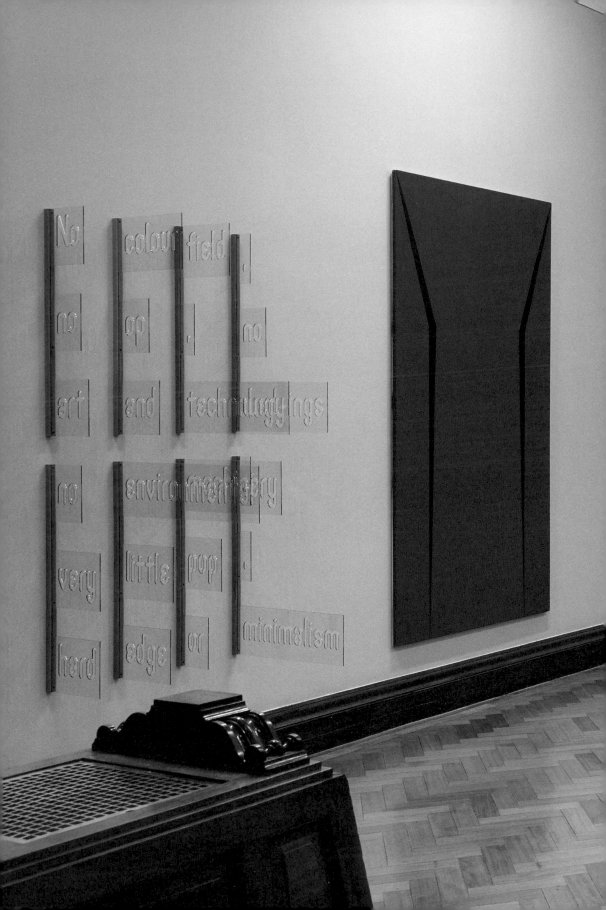

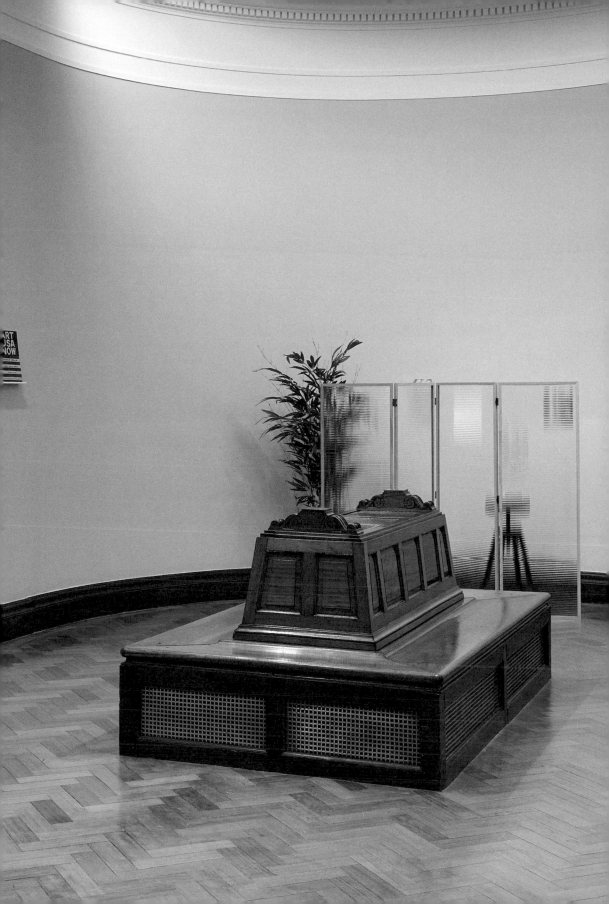

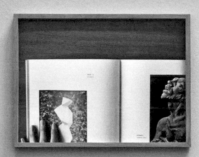

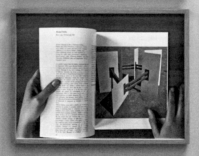
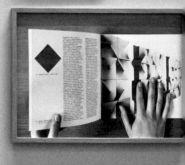

JANUARY 1964

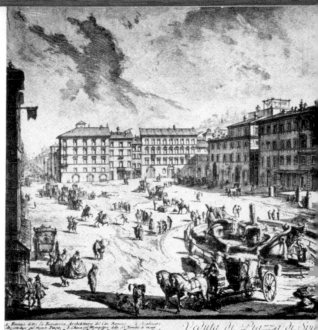

EXHIBITION

OF

ENGRAVINGS

OF THE "CALCOGRAFIA NAZIONALE

ITALIANA"

ISTITUTO IT... ANO

Michael Bulfin

Born 1939, Devinlough, Birr

He was educated at Birr, University College, Dublin, and Yale University, Connecticut, U.S.A. He is mainly self taught and held his first one-man exhibition in the Project Gallery, Dublin, 1970. Other exhibitions include the Irish Exhibition of Living Art, 1966, 1968 (prizewinner—adjudicators special award), 1969 (Honorary Mention) and 1970; Oireachtas Exhibition 1969 and Independent Artists Exhibition 1970.

A scientific (rather than an artistic) education has had an important effect upon Michael Bulfin's outlook as a sculptor and upon the sculpture which he has produced. Although he has been working with a number of different materials for about 13 years, it was not until 1963 that he found himself inexorably committed to being an artist—at the same time recognising the practical difficulties which the sculptor (rather ~~re~~ than the painter) must face in this country. ~~quite~~ a number of the younger Irish artists of ~~were~~ studying at the College of Art in Dublin, ~~ael~~ Bulfin was taking a science degree at the ~~tional~~ University. Now that he has, so to speak, ~~a~~ foot in either world, he is all the more ready to identify the points of convergence of 'art' and 'technology' than to view them (as do many of his contemporaries) as totally disparate. He is both artist and craftsman; the intensity which suffuses his work is a reflection of his intense absorption in the technique of metalwork or carpentry or whatever it happens to be.

Michael Bulfin views with a baleful eye the situation whereby the public is normally much more ready to invest in painting than in sculpture. In order that sculpture may reach a wider domestic public he has recently been creating multiples, mainly in perspex; many of these are in a distinctly architectural vein. He has found that this medium has subtle colour qualities—natural changes of light invest it with a new intrigue. Colour, indeed, now assumes a heretofore neglected place in his sculpture (he is doing very little two-dimensional painting at present)—his immense 'Serrem' (i.e. serrated M) has its solid section in a startling petunia, the uprights in stippled grey; 'Serra III' (9 ft high × 20 ft long), which will be at the Paris Biennal, is a brilliant red; in the

present exhib...
is an integral p...
Michael Bulf...
graphy: he find...
He is uncomp...
of our time...
presentation...
half-measure...
closer to the o...
other, but ca...
sculptor whose...
though he ach...
Perhaps an ea...
from aluminium...
been punched...
"romance of p...
(like Smith) he r...
avoidance of tru...
Michael Bulfin...
negation of the b...

Christopher F...

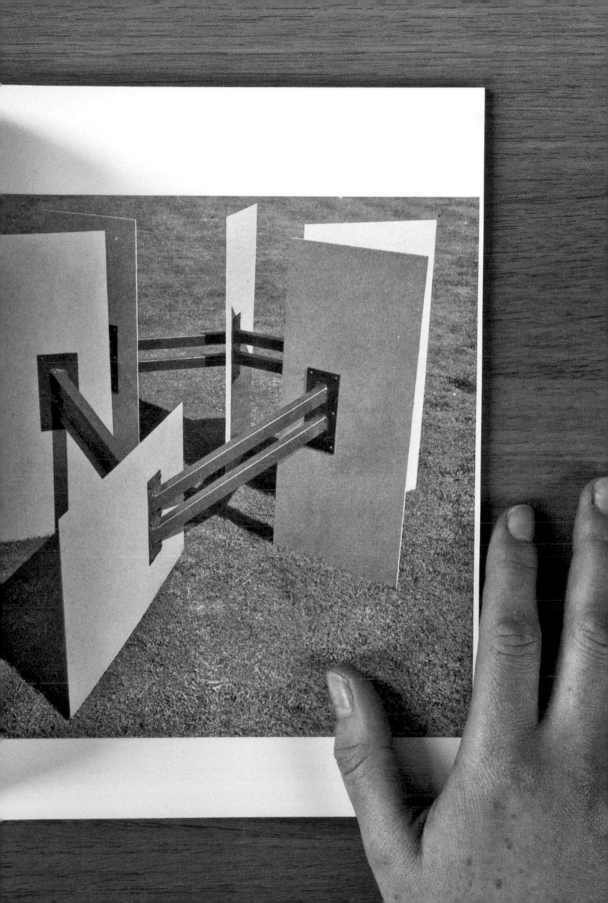

II Art and Society

2 Protest

PETER KLASEN

Born in 1935 in Lübeck. Went to France in 1959. Studied at the School of Fine Arts in Lübeck from 1956 to 1959. Won the Franz Roh Prize in 1967. Exhibited at the Friedrich Gallery in Munich in 1964.
One-man exhibitions: 1966, Galerie Mathias Fels, Paris and Ad Libitum Gallery in Anvers; 1967, Studio Bellini, Milan; 1968, Galerie Mathias Fels, Paris.
Group exhibitions: 1959, 'Ars Viva', Leverkusen-Nuremberg (1960); 1964, 'Mythologies quotidiennes', Art Moderne de la Ville de Paris; 1965, 'Les Néo-individualistes', Brussels, Berlin, Paris, organised by Iris Clert; 1967, 'Portraits', Galerie Claude Bernard; 'Bandes dessinées et figuration narrative', Musée des Arts décoratifs; 1968, L'Art vivant de 1965 a 1968', Fondation Maeght. Won the Marzotto Prize. Has contributed to the different Paris Salons as well as various group exhibitions throughout the world.

No. 30

29 **Stethoscope No. 6**
oil/canvas, objects fixed to the canvas
130 × 97 × 7
Lent by the artist

30 **Femme bandée ~~~ls tétines (band-aged woman + ~~~ teats)**
acrylic on can~~~ objects fixed to
canvas
~~~30 × 97 × 10
~~~nt by the ar~~~

~~~NCISCO SOBRINHO

~~~in Guadalajara, Spain, in 1932. Co-~~~der of the 'Groupe de Re~~~es ~~~Visuel' in 1960, whose sec~~~ ~~~was held in his own stud~~~ ~~~Denise René Gallery in ~~~ ~~~part in numerous exh~~~ ~~~pe and elsewhere and is re~~~ ~~~principal Paris Salons.

**Déplac~~~ ~~~table FG**
~~~lexigla~~~ ~~~rome)
~~~60 × 30~~~
~~~Galerie Den~~~ ~~~, Paris

Colonne
~~~lexiglass
~~~70.5 × 10.5~~~
~~~Galerie Den~~~ ~~~ris

**Structure peri~~~ ~~~CA 3**
~~~stainless steel,~~~
~~~100 × 100 × 5~~~
~~~Galerie Denise ~~~

Gavin Murphy
We look at the past through coloured glass

Emile, or On Education[1]

"We are born with the use of our various senses, and from our birth we are affected in various ways by the objects surrounding us. As soon as we have, so to speak, consciousness of our sensations, we are disposed to seek or avoid the objects which produce them, at first according to whether they are pleasant or unpleasant to us, then according to the conformity or lack of it that we find between us and these objects, and finally according to the judgements we make about them on the basis of the idea of happiness or of perfection given us by reason. These dispositions are extended and strengthened as we become more capable of using our senses and more enlightened; but constrained by our habits, they are more or less corrupted by our opinions. Before this corruption they are what I call in us *nature*."
— Jean-Jacques Rousseau (1762)

1
Culture and meaning in the museum

"Visual culture as a field of study raises theoretical questions about the social practices of looking and seeing, which are related to processes of learning and knowing. It is concerned with artefacts, but also examines the social institutions and practices that act as visual apparatuses which frame those artefacts. Visual culture works towards a social theory of visuality, focusing on questions of what is made visible, who sees what, how seeing, knowing and power are interrelated."

One of the functions of the public museum, simply put, is to present *material culture* to be viewed: museums were intended to *speak to the eyes*. The organising principles of displays, based on the basic structures of specific subject areas, were therefore intended to transmit and teach those structures. Diverse objects from a range of sources are sorted, classified, and ordered through display into a visual narrative, with each individual item given its significance by being placed within a larger group. At the same time museums were also charged with demonstrating – and thereby transmitting – the basic principles of citizenship through clean and ordered spaces where controlled behaviour could be observed.[2]

[In this environment] socially minded work would inevitably be affected by the terms of any setting that could, significantly, be called – to quote theorist Tony Bennett in *The Birth of the Museum* – 'a space of observation and regulation in order that the visitor's body might be taken hold of and be moulded in accordance with the requirements of new norms of public conduct'. Turning to Foucault's 1984 essay *Of Other Spaces*, Bennett cites the philosopher's observation that the museum in Western culture manifests 'the will to enclose in one place all times, all epochs, all forms, all tastes, the idea of constituting a place of all times that is itself out of time … the project of organising in this a sort of perpetual and indefinite accumulation of time in an immobile place.'"[3]

2
Picturing the ancestors and imag(in)ing the nation

"Museums are major apparatuses in the creation of national identities, whereby the nation is presented as cultured, and elevated in taste."[4]

Department of the President, February 22nd, 1932
The Executive Council of Saorstat Eireann [The Irish Free State] have commissioned Dr. Bodkin to write this book because of his long and intimate association with Sir Hugh Lane, because of his experience as a writer on matters concerning art, because he holds as Director of the National Gallery of Ireland the post in which Lane took such pride, because his legal qualifications fit him to state Ireland's case for the return of Lane's modern pictures, and because Lane, in the codicil of his will, expressed the wish that "my friend Tom Bodkin should be asked to help".

The Executive Council issue this book as an outline of Ireland's case [in relation to Hugh Lane's conditional gift of Continental pictures], in the confident hope that it will be found to be irresistible on equitable grounds.[5]

The French historical painter Vincent Léon Pallière (1787–1820) had a studio in the Villa Medici in Rome and in a painting by Jean Alaux (1786–1864) he is depicted in his studio there in 1817, before an open window playing the guitar, surrounded by prints and casts. Pallière remained in Rome for five years, where he painted subjects from classical history. Alaux also painted the studio of JAD Ingres, who had a studio in Rome around this time.[6]

Portraits make particularly powerful visual statements. Presented as a display, groups of portraits illustrate relationships between people, demonstrating the importance of certain groups through their inclusion and, by implication, the lack of importance of those not represented. The pedagogic role of portrait galleries

PUBLISHED ON THE OCCASION of
Sleepwalkers: Gavin Murphy
In Art We Are Poor Citizens
Dublin City Gallery The Hugh Lane
20 February – 25 May 2014

List of works (left to right):

**We look at the past
through coloured glass**
2014, four-page text

Andrew O'Connor
The Head of a Child
Marble, 35 × 35.5 × 22.5 cm
Presented by the Artist, 1939
Collection Dublin City Gallery The Hugh Lane, Reg. 866

**Preface
Hugh Lane and his Pictures**
by Thomas Bodkin (reproduction)

Charles François Daubigny
Tombeau de Jean-Jacques Rousseau
1866, pencil on paper, 33.6 × 49.5 cm
Presented by Mrs Aileen Bodkin
in memory of Dr Thomas Bodkin, 1963.
Collection Dublin City Gallery The Hugh Lane, Reg. 1215

1. Rousseau's Émile is half treatise, half novel, considered Rousseau's high statement of his philosophy of education and a groundbreaking work in educational reform. **2.** Hooper-Greenhill, Eilean, **Museums and the Interpretation of Visual Culture**, New York, Routledge, 2000, p. 14. **3.** Griffin, Tim, 'Postscript: The Museum Revisited', Artforum, 'The Museum Issue', Summer 2010 pp 330–331. **4.** Hooper-Greenhill, p. 24. **5.** Bodkin, Thomas, **High Lane and his Pictures**, published by the Pegasus Press (London) for the government of the Irish Free State, 1932. Each plate accompanied by leaf with descriptive letterpress, not included in the pagination. This first edition is limited to 400 copies by order of the government of the Irish Free State. Text composed in Pastonchi type and printed by the Officina Bodoni, Verona. The plates are printed in double-tone collotype by Messrs. F Bruckmann, Munich. Manufacture supervised by Hans Mardersteig of Verona. **6.** O'Donnell, Jessica, **The Collection Revealed, The Perceptive Eye: Artists Observing Artists**, Dublin City Gallery The Hugh Lane, 2010. **7.** Eilean Hooper-Greenhill, p. 23. **8.** Charlemont House, the home of Dublin City Gallery The Hugh Lane, was designed by William Chambers and built in 1765 for James Caulfeild (1728–1799) 4th Viscount Charlemont and 1st Earl of Charlemont (he was also the first president of the Royal Irish Academy). The addition of the main ground-floor galleries, designed in 1929 by the then City Architect, Horace T. O'Rourke were erected over what was once the sculpture garden of Charlemont House. **9.** Kaufman, Walter, Translator's introduction, Friedrich Nietzsche, **The Gay Science** (1887). **10.** Title of a press release by the Contemporary Irish Art Society. Collection National Irish Visual Arts Library, File: Hugh Lane 1950s–90s.

is thus open to being a moral one, achieved through the assembling and bringing to meaning of certain pieces of visual culture.[7]

INTERLUDE
Architecture for the search of knowledge

"One day, and probably soon, we need some recognition of what above all is lacking in our big cities: quiet and wide, expansive places for reflection [...] buildings and sites that would altogether give expression to the sublimity of thoughtfulness and of stepping aside.

We wish to see *ourselves* translated into stone and plants, we want to take walks *in ourselves* when we stroll around these buildings and gardens."[8]
— Friedrich Nietzsche, *The Gay Science* (1887)

The first English translation of *Die fröhliche Wissenschaft* was entitled *The Joyful Wisdom*, which quite misses Nietzsche's meaning. *Wissenschaft* means science and never wisdom. He himself had called his book: *Die fröhliche Wissenschaft* or *The Gay Science*, which, while having 'joyful' overtones, also points to a light-hearted defiance of convention; and suggests Nietzsche's 'revaluation of values'.

What Nietzsche himself wanted the title to convey was that serious thinking does not need to mean joyless, heavy or, in a word, *Teutonic*. Equally, the German word *Wissenschaft* does not necessarily mean the natural sciences but any serious, disciplined, rigorous quest for knowledge; and this need not be of the traditional 'Teutonic' type or, as Nietzsche is fond of saying in his book, *northern*; it can also be *southern*, and he refers again and again to Genoa and Provence. It was in Provence that modern European poetry was born, and it is William IX, the Count of Poitiers around 1100 AD whose verses are said to be the oldest surviving lyrics in a modern European language.[9]

3
Who we are and What we purpose[10]

The orange-bulging sun burns
 its own light,
Dissolves in dribbles down the
 vacant sky;
I see a spider's molten centred
 web
High over Hiroshima,
 Nagasaki.[11]

The Contemporary Irish Art Society was founded by a group of Irish citizens in 1962, its object to present modern Irish works to Irish galleries. By 1968 this society had presented some 21 works to the Municipal Gallery, valued in all at approximately £4,000. One of the Society's early purchases was *Solar Device* by Patrick Scott. One of the most striking pictures in the

Irish collection, it consists of two unprepared canvases mounted in one frame; the top a wild blaze of colour, the bottom by contrast the negative buff colour of the raw canvas. The work is one of a series of paintings in which Scott protested against the H-bomb testing of the day through forms that recall the deadly beauty of the bombs radiating halo. "The ambiguity of calling them devices and the reason for still testing weapons of mass destruction, which had already been used with such tragic consequences in Hiroshima and Nagaski, left me outraged", he said (Scott's mature work is said to be partly inspired by the Japanese flag).[12]

In 1904 the then director of the National Museum of Ireland, expressed to Lady Gregory his view that he "hoped never to see a picture hung in Dublin until the artist had been dead one hundred years". At the same time a prominent art collector, Sir Hugh Lane, who was trying to secure a home for his conditional loan of continental pictures opined:

"... there is not in Ireland one single accessible collection or masterpiece of modern or contemporary art ... A gallery of Irish and modern art in Dublin ... would be necessary to the student if we are to have a distinct school of painting in Ireland, for it is one's contemporaries that teach one the most. They are busy with the same problems of expression as oneself, for almost every artist expresses the soul of his own age."[13]

In January 1940 the Friends of the National Collection held their fourth annual reception in The Municipal Gallery (it was largely due to their efforts that Charlemont House was secured for Dublin as a gallery of modern art). Miss Sarah Purser explained they were carrying out the intentions of Sir Hugh Lane, who had tried in vain to found a modern gallery worthy of the capital. Lane had said: "I am afraid that in matters of art we are poor citizens. We never seem to realise that a little practical help and recognition at the right time is worth far more than a lot of useless sympathy when the opportunity has been missed."[14]

4
Wandering souls

Members of Dublin City Council's Art Advisory Committee met yesterday in the Municipal Gallery to inspect its recent purchases. It was the view of some that the public's money had not been spent wisely, Alderman Ned Brennan said he was having difficulty 'relating' to the works. The committee which is composed of members of Dublin Corporation and others 'interested in art', has the power to decide if a picture is of sufficient merit to hang in the Municipal, however the gallery

11. *Solar Device* inspired this verse by Dublin poet Basil Payne (one of three verses composed by Payne on three abstract works in the collection). **12.** Waldron, Eithne, Curator, Municipal Gallery of Modern Art. 'Treasures of Ireland: The Municipal Gallery, Dublin', **Irish Independent**, Tuesday, June 11, 1968. **13.** Hugh Lane, from his introduction to **Exhibition of a Selection of Works by Irish Painters**, 1904, Guildhall, London. **14.** 'Art lovers meet in Charlemont House', Irish Press, Friday, January 26, 1940. **15.** The Irish Times, February 29, 1952; January 21, 1986; and January 13 1987. **16.** Scott, Yvonne, 'Paul Klee's 'Anima errante' in the Hugh Lane Municipal Gallery, Dublin', The Burlington Magazine, Vol. 140, No. 1146 (September, 1998) pp. 615 – 618. **17.** Hooper-Greenhill, p. 14. **18.** Monaco, James F., **The New Wave**, Oxford University Press, USA; 1st edition (September 22, 1977). **19.** Jankowiak, Steve, 'Le Gai savoir', Senses of Cinema, online journal. Issue 42, January – March 2007, http://sensesofcinema.com/2007/42/gai-savoir/. **20.** O'Doherty, Brian, catalogue introduction for **The Irish Imagination 1959 – 1971**, "a major exhibition of painting and sculpture" held at Dublin Municipal Gallery of Modern Art, in association with Rosc '71, October – December 1971. **21.** 'Magnificent exhibition of U.S. paintings', The Irish Times, Thursday, April 16, 1964. **22.** Kissane, Sean, **Cecil King – A Legacy of Painting**, Irish Museum of Modern Art, 2008. **23.** 56 Group Wales was founded in Cardiff in 1956. Despite having its detractors, the Group nonetheless played a significant role in stimulating awareness of contemporary art and in raising the profile of the professional artist in Wales. A substantial tour of the Republic of Ireland and Northern Ireland occurred in 1968 – 1969, arranged by their respective arts councils. Full list of artists in

seems fated to be involved in controversy every time it attempts to make a major purchase. There was the pale abstract painting by Agnes Martin bought after the 1980 *Rosc* (popularly believed to be a blank canvas although it wasn't), the affair of the Beuys blackboard, almost forgotten now, and back further still, the committee decided not to accept from a 'group of Dublin people' a gift of Louis Le Brocquy's *The Family* (although the members of Dublin Corporation on the committee were in favour of accepting it). [15]

One of two little-known works by the artist in the collection of the Hugh Lane Municipal Gallery of Modern Art in Dublin, Paul Klee's *Anima errante* was donated under the terms of the Charles Bewley Bequest in 1969. Bewley himself was a controversial and enigmatic figure. He won the Newdigate Prize for English verse while at New College Oxford in 1910 (previously won by such figures as John Ruskin and Oscar Wilde), served as a barrister, and subsequently as a diplomat, first in the Vatican, and then Berlin from 1933–1939. Taking a decidedly anti-British and pro-Nazi stance he was forced to resign, and following the war retired to Rome where he lived at Via Antonelli, surrounded by a small collection of pictures. The original title *irrende Seele 1*, is handwritten on the mount (it is known now as *Anima errante* because Bewley's inventory was drawn up in Italian). The work appears never to have been published: it is recorded in Klee's handwritten catalogue of over 9000 works with a date of 1934, but is one of very few whose whereabouts had not been identified there. It was, however, recorded by Will Grohmann, Klee's biographer, in a sketch he took at Klee's studio, one of hundreds of 'aide mémoires'. That drawing, now in Stuttgart, is unmistakeably of the Dublin work. [16]

INTERLUDE
Visual Culture as a concept

'Whereas 'culture' as an idea can be traced back to the late Middle Ages, 'visual culture' is a new concept and an emerging field of study. It can be seen as an encounter between sociology and fine art, or the application of theories from social and cultural studies to those artefacts and practices that would conventionally be included within art history, such as painting, sculpture, and architecture. Visual culture, however, also broadens its focus to include other visual media, such as advertisements, family photographs, television and film." [17]

The film *Le Gai Savoir* (English title *The Joy of Learning*) is one of the very rare examples of the medium of cinema, which is almost pure intellectual discourse. The structure of the film employs a series of seven late-night dialogues in an unused television studio during

which Patricia Lumumba, the Third World delegate to the Citroen auto plant, and Émile Rousseau, great-great-grandson of Jean-Jacques, try to develop a rigorous analysis of the relationship between politics and the image, via a poetic essay that is unusually difficult to discuss it in still another medium:

"Let's start from zero," Émile says. "No," Patricia replies, "it is necessary to return to zero first." (It is necessary to dissolve sounds and images in order to analyze them). "Images: we meet them by chance, we don't choose them. Knowledge will lead us to the rules for the *production* of images." […] (Video pictures and sounds). "The first year we collect images and sounds and experiment. The second year we criticize all that: decompose, recompose." [18]

At the end of the second night, Patricia initiates a dialogue devoted to civic education, the main concern of Rousseau's treatise, *Émile, ou De l'education*, on which the film is loosely based. [19] In *Émile* Rousseau proposed a radical approach to education where children must be encouraged to reason their way through to their own conclusions and not rely on the authority of the teacher. Instead of being taught other people's ideas, Émile is encouraged to draw his own conclusions from his own experience. What we know today as 'discovery learning'.

5
Cultural politics in the museum

The magnificent exhibition of American art – USA ART NOW – at the Municipal Gallery is the biggest event of its kind here in years. It has a rare sweep and comprehensiveness about it, grinds its axes – if any – in silence and treats its vast panoramic theme in terms of artists rather than schools. Exhibitions like these are important for Dublin, as there is no substitute for the physical presence of a painting; reproductions are a treacherous medium, especially with large pictures, as the majority of these are. They strike you – oh rare thing – as being included on their individual merit, not as a critical or historical index. [21]

The experimental style of painting which has become known as 'hard-edge' painting, derives its name from British art critic Lawrence Alloway's response to seeing *Four Abstract Classicists*, an exhibition curated by Jules Langsner which featured the work of Californian painters Karl Benjamin, Lorser Feitelson, Frederick Hammersley and John McLaughlin, and which opened at the Los Angeles County Museum of Art in 1959. The exhibition went on to tour to San Francisco, London, and Belfast. Although it is uncertain as to whether the Irish artist Cecil King saw the exhibition in London or Belfast, what can be more certain is the impact on his work of the subsequent exhibitions of abstract artists that were exhibited in Dublin – *Art USA Now* in 1964

Paul Klee
Anima errante (irrende Seele)
1934, stylus drawing on paper prepared with red wax/paint ground, 18 × 27 cm
Bequest of Mr C. Bewley, 1969
Collection Dublin City Gallery The Hugh Lane, Reg. 1297

aide mémoire
2014, framed acid-free paper, laser-cut acrylic, 31 × 42.5 cm
Edition of 5 unique versions and 1 AP

Why has Ireland not displayed these international symptoms? [20]
2014, laser-cut acrylic, fabricated wooden mounts, 170 × 84 cm
Edition of 1 and 1 AP

Cecil King
Nexus
1973, oil on canvas, 221 × 122 cm
Presented by the Contemporary Irish Art Society, 1974
Collection Dublin City Gallery The Hugh Lane, Reg. 1495

USA Art Now
1964, poster (34 × 24 cm) and fabricated shelf
Collection National Irish Visual Arts Library

Dublin exhibition: Vyn Baldwin, Laurie Burt, Arthur Giardelli, Tom Hudson, Robert Hunter, Heinz Koppel, Brian McDonald, Eric Malthouse, Keith Richardson-Jones, Eric Rowan, David Saunders, John Selway, Terry Setch, Christopher Shurrock, Jeffrey Steele, Anthony Stevens, David Tinker, Norman Toynton, Michael Tyzack, Alan Wood, Ernest Zobole. Sources: David Moore, **A Taste of the Avant Garde, 56 Group Wales 56 Years**, Crooked Window Press, 2012, and **56 Group Wales** (exhibition catalogue), 1968, The Municipal Gallery of Modern Art, Dublin. **24.** A4 envelope of photographs, (The Green Studio Ltd.) Ref FE/60c, 62b, 63a. Collection National Irish Visual Arts Library, File: Hugh Lane 1950s–90s. Image features left to right on wall: Robert Hunter, **Celtic Invitation**, Oil, paper mache, string; Vyn Baldwin, **Column Fallen Under Its Stone**, polyester resin, fibreglass; Laurie Burt, **Seen From the Upper Surface**, Acrylic on board; John Selway, **Le Dejeuner sur L'Herbe**, Oil on Canvas; Ernest Zobole, **A Picture of the Sea and Some Land**, Oil on Canvas; Foreground: Anthony Stevens, **Mats**, Latex, 12 mats each approx. 30 × 12"; Brian McDonald, **Stack**, Stainless steel, 48 × 66 × 60". **25.** Hooper-Greenhill, p. 112. **26.** Hooper-Greenhill, p. 118. **27.** Dana p. 25. **28.** Evening Mail, October 26, 1961. **29.** Evening Press, January 17, 1962. **30.** Mouffe, Chantal, Professor of Political Theory, University of Westminster, London, in **Artforum**, 'The Museum Issue', Summer 2010, p. 327. **31.** Hooper-Greenhill, p. 152.

and *Rosc* in 1967 – bringing King into contact with such artists as Ad Reinhardt, Hans Hartung, Lucio Fontana, Pierre Soulanges, Sam Francis, Kenneth Noland and Barnett Newman. [22]

6
Interpreting objects

"Encounters with objects are not the same as encounters with ideas. Ideas, concepts, words, are abstract and non-material. They demand verbal and linguistic skills in their understanding. Ideas need to be placed within intellectual frameworks of intelligibility and comprehension before they 'make sense'. Cognitive processes are necessary.

The exchange between object and viewer is more than a cognitive one. The encounter between an active agent and an object has two sides to it: the interpretive framework brought to bear by the individual subject, which is both personal and social, and the physical character of the artefact. The material properties and the physical presence of the artefact demand embodied responses, which may be intuitive and immediate. Responses to objects are culturally shaped, according to previous knowledge and experience, but the initial reaction to an object may be at a tacit and sensory rather than an articulated verbal level." [25]

The process of interpreting objects is complex and active, whereby individuals search for meaning, look for patterns, try to invest each experience with significance. Within the humanities and the social sciences it has come to be acknowledged that there is no knowledge outside the knower, that knowledge is brought into being by the meaning that each individual makes of the experiences he or she has. This is 'social construction' in social science; 'constructivism' in learning theory; or 'interpretation' in literary theory and archaeology. [26]

7
To make itself alive, a museum must do two things: It must teach and it must advertise

"It may be said that a collection of art objects properly housed in a beautiful building gains somewhat in dignity and importance and in its power to influence beneficially those who visit it if it is set apart a little from the city's centre of strenuous commercial and material life; holds itself somewhat aloof, as it were; detaches itself from the crowd; and seems to care to speak only to those whose desire for its teachings is strong enough to lead them to make some sacrifice of time and money to enjoy them.

The suggestion is a specious one. This theory of the fitness of remoteness is born of pride and satisfaction in the location and character of museums as they are. The buildings are remote and are religious or autocratic or aristocratic in style; their administrators, perhaps in part because of this very aloofness and sacrosanct environment, are inclined to look upon themselves as high priests of a particular cult, who may treat the casual visitor with tolerance only when he comes to worship rather than to look with open eyes and to criticize freely" [...] [27]

Plans to popularise the Municipal Gallery and "bring the art to the people" are being put into operation by the new curator, Mr. James White. Some of them are sensationally novel plans, which make a clean break with the whole tradition of the gallery. One of the more dramatic innovations will be the provision of little transistor recorders, which, by the use of earphones, will whisper a commentary for a tour of the gallery as the visitor walks around. [28] Mr. White, abhors the *traditional* idea of a whispering gallery. [29]

Today many museums can be said to have abandoned their original purpose of educating citizens into the dominant culture and have instead transformed themselves into "sites of entertainment" for a public of consumers. The type of "participation" they promote is based on consumerism, and they actively contribute to the commercialisation and de-politicisation of the cultural field. There may have been a time when it would have made sense to abandon the museum entirely in order to nurture the development of novel artistic practices, however, another path can be envisaged … under present conditions, with the art world almost totally colonized by the market, the museum is uniquely positioned to become a sanctuary from commercial interests … a privileged place for artworks to be presented in a context that allows them to be distinguished from commodities. [30]

In the modernist museum, display is the major form of communication – this transmission approach to pedagogy has severe limitations. In the 'post-museum' the exhibition will become one among many other forms of communication, part of the nucleus of events which will take place both before and after the display is mounted. These events might involve the establishments of community partnerships; the production of objects during educational programmes, which then enter the collections; the hosting of writers, scientists and artists in residence; or satellite displays set up in pubs and shops. During these events, discussions, workshops, performances, dances, songs and meals will be produced or enacted.

Knowledge is no longer unified and monolithic; it becomes fragmented and multi-vocal. There is no necessary unified perspective – rather a cacophony of voices may be heard. [31]

Sleepwalkers is an ongoing project in which six artists – Clodagh Emoe, Jim Ricks, Sean Lynch, Linda Quinlan, Lee Welch and Gavin Murphy – have collectively used the gallery as a place for research. The first phase attempted to reveal the process of conceiving an exhibition by the display of work and ideas in progress. This process resulted in each artist developing a solo exhibition at The Hugh Lane.

Compiled and edited by Gavin Murphy. Designed by Oran Day. Photography, **Six Views of The Municipal Gallery** by Gavin Murphy and Emma Haugh. Reproductions by Exhibit A.

Thanks to: Michael Dempsey; Logan Sisley; Jane McCree and all the staff of Dublin City Gallery The Hugh Lane; Katy Fitzpatrick; Oran Day; Emma Haugh; Philip White; Morris Deegan, Frame Foundry; Dominic Turner; Exhibit A Studios; Michael Daly; Fire Station Artists Studios; Pallas Projects/Studios; John Gallagher; Urban Plant Life; Jennifer Fitzgibbon and the staff of the National Irish Visual Arts Library (NIVAL); David Moore, John Selway, Dilys Jackson (56 Group Wales); Oliver Dowling.

pp. 141–48
Installation views,
Gavin Murphy, *In Art We Are
Poor Citizens,* Gallery 8, Dublin
City Gallery The Hugh Lane,
20 February – 25 May 2014

p. 141, left:
Andrew O'Connor
The Head of a Child
Marble
35 × 35.5 × 22.5 cm
13 ¾ × 14 × 8 ⅞ in

p. 141, middle:
'Preface' from *Hugh Lane
and His Pictures,* by Thomas
Bodkin (reproduction)

p. 141, right:
Charles François Daubigny
*Tombeau de Jean-Jacques
Rousseau,* 1866
Pencil on paper
33.6 × 49.5 cm
13 ¼ × 19 ½ in

p. 142
Jean-Auguste-Dominique
Ingres, *Portrait of Vincent Léon
Pallière,* c. 1810–20
Oil on canvas
40.7 × 32.3 cm
13 ¼ × 19 ½ in

p. 143
Gavin Murphy
In Art, We Are Poor Citizens,
2014
Laser-cut acrylic, fabricated
wooden mounts
80 × 84 cm
31 ½ × 33 ⅛ in

p. 144, left:
Gavin Murphy
*Why has Ireland not displayed
these international symptoms?,*
2014
Laser-cut acrylic, fabricated
wooden mounts
170 × 84 cm
66 ⅞ × 33 ⅛ in

p. 144, right:
Cecil King
Nexus, 1973
Oil on canvas
221 × 122 cm
87 × 49 ⅛ in

p. 145, left:
USA Art Now, 1964
Poster
34 × 24 cm
13 ⅜ × 9 ½ in

p. 145, right:
Gavin Murphy
*Knowing objects in their
materiality,* 2014
Dimensions variable
4 screen panels, potted
bamboo, catalogue for
*Tradition in Modern Japanese
Production* (The Municipal
Gallery of Modern Art, 1964),
The Gay Science by Friedrich
Nietzsche, studio stool, foam
blocks and reproductions of
Hugh Lane and His Pictures by
Thomas Bodkin, invite card
for *The Sculpture of Alexander
Archipenko,* photograph of
56 Group Wales

pp. 146–47
Gavin Murphy
*Knowing objects in their
materiality,* 2014 (detail)

pp. 148–52
Gavin Murphy
*Six views of The Municipal
Gallery,* 2014 (details)
Framed photographic
archival prints
Dimensions variable

Catalogue credits featured in
the three details of *Six views
of The Municipal Gallery:*

p. 149
*Exhibition of Engravings of the
Calcografia Nazionale Italiana,*
presented by The Italian
Institute in Dublin in the
Municipal Gallery of Modern
Art, January 1964; Catalogue
by Gilberto Ronci, Director
of the Calcografia Nazionale
Italiana; Edited by Elsa
Gerlini, Director of The Italian
Institute; Cover: Giambattista
Piranesi (1720–1778), *Piazza di
Spagna,* 1750 (No.1400/707)

pp. 150–51
*The Irish Imagination
1959–1971,* in association with
Rosc '71. Municipal Gallery
of Modern Art, Dublin,
23 October–31 December 1971.
Catalogue compiled by Brian
O'Doherty, Dorothy Walker,
Oliver Dowling, Amanda
Douglas, Carol Hogan, Tony
Hickey and Jeanne Sheehy;
Design and cover by Peter
Wildbur; Photography by
Fergus Bourke and Louis
Pieterse; Printed by Irish
Printers Ltd. Dublin. Image:
Michael Bulfin (b. 1939, Birr),
not titled/credited

p. 152
*Three Trends in Contemporary
French Art,* Municipal Gallery
of Modern Art, Dublin,
26 February–28 March
1971. Organised under the
auspices of the Government
of the Republic of France, by
l'Association Francaise d'Action
Artistique and presented
by the French Embassy and
An Chomhairle Ealaíon/
the Arts Council. Artistic
Director: M. Julien Alvard;
Assistant Artistic Director:
Mlle. Jacqueline Heriard-
Dubreuil; catalogue designed
and printed in Ireland at the
Dolmen Press Dublin. Images:
Luigi Tomasello (b. 1915,
Argentina), *Atmosphere
chromoplastique, No. 178,*
wood (relief), 76 × 196 × 12 cm;
Peter Klasen (b. 1935,
Lubeck), *Femme bandée +
trios tétines,* acrylic on canvas
and objects fixed to canvas,
130 × 97 × 10 cm

pp. 153–56
Gavin Murphy
*We look at the past through
coloured glass,* 2014
Lithographic print on paper
31 × 22 cm
12 ¼ × 8 ⅝ in
Original layout designed
by Oran Day

Too Hot to Run for President
Linda Quinlan

A preview of a future exhibition

Weaving a kind of visual alchemy in her work that choreographs a playful set of relations between thermodynamics and epistemology, Linda Quinlan meditates on themes that determine our understanding of the material world and our relation to it. Burrowing deep into these forces, her work invites the viewer to recognise and unlearn established conceptions of Western thought by eluding its dead-end nature with hope and insightful meaning.

'In developing work for my *Sleepwalkers* exhibition, I wish to engage the dynamic principals of matter and energy as a way to explore and trace their interfacing with human history, encounters that give rise to cultural phenomena and the technological climate we inhabit today.' [1]

Working across various media Quinlan's work explores connectivity and in doing so heat and light become the conduits, the catalysts, for her inquiry. She draws on discussions that consistently return to theories that reflect on societal bonds, power relations, systems of meaning, abstraction and belief.

'In making the images for the publication, I engaged in a process of sheering away or subtracting any weight from the images as a way to infuse a certain lightness and aerial quality.' [2]

[1] Linda Quinlan in conversation with Michael Dempsey, October 2014.
[2] *Ibid.*

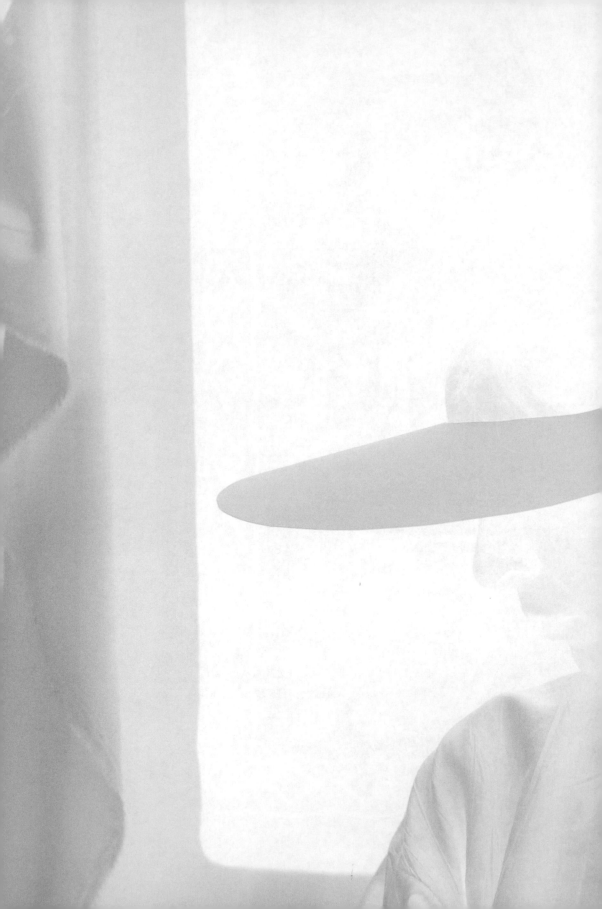

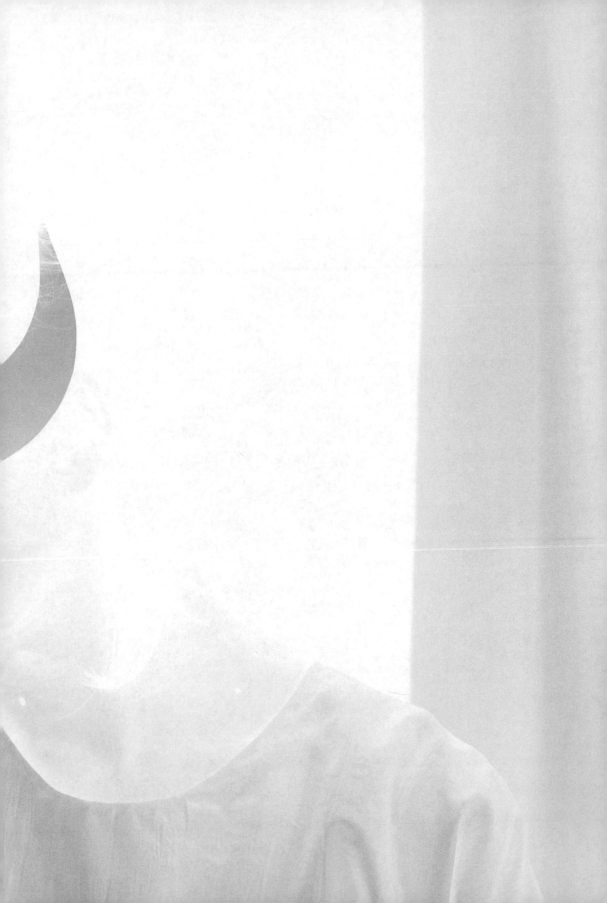

Soft Power
Hard Candy

Mother tongue
father land

Dry humour
Wet chemistry

pp. 159–72
Pages by Linda Quinlan

pp. 175–97
At the very beginning of
the *Sleepwalkers* project
the six artists were
introduced to Karsten
Schubert's *The Curator's
Egg* (2009, fourth edition)
as a catalyst to start the
process.

Original layout designed
by Richard Hollis with
Marit Muenzberg.

1.
Democracy of Spectacle:
The Museum Revisited

The present order is the disorder of the future.
Saint-Just[168]

There is nothing more easily destroyed than the equilibrium
of the fairest places.
Marguerite Yourcenar[169]

Since *The Curator's Egg* was first published nine years ago much
has changed in the museum world. While the historical facts
remain the same, the current trends and debates that I set out
and the conclusions I drew at that time require elaboration, cor-
rection and update. As always, when trying to predict the future
one can only extrapolate from the present. Yet reality moves in
strange and unpredictable ways, as is the case here. The cultural
landscape has altered greatly since the turn of the millennium.
What then seemed vague trends are now established truths. The
public and professional debate about museums, already shrill
a decade ago, has since become even more aggressive, partisan
and often self-serving and dogmatic. It would be no exaggera-
tion to describe it as a battle for the life and soul of the muse-
um. The battle lines are drawn between, on the one hand, those
who align themselves with the new museums as a great success
story, over-run with visitors, the latest entrant in the 'cultural-
industry' league, and, on the other, the keepers of the flame, the
defenders of an old museum ethos, invoking primarily scholar-
ly and educational goals. At one point, it seemed, this conflict
could be sketched out by comparing Tate Modern in London on
one side of the Atlantic and the Museum of Modern Art in New
York on the other. This was a seductive pairing and made for
noisy discussion because it allowed each side to denounce the
other as destructive and vulgar or elitist and out-of-touch. The
ready-made simplicity of this black-and-white argument has

168
Norman Hampson,
Saint-Just (Oxford: Basil
Blackwell Ltd, 1991).

169
Margaret Yourcenar,
*Memoirs Of Hadrian
and Reflections of the
Composition of Memoirs
of Hadrian* (London:
Penguin, 1986), p 288.

been irresistible for many authors and critics. Yet, like all simplistic readings, it does not reflect reality and has obscured the complexities of the issues at stake. In the end, this is not a conflict between the keepers of the flame and the new barbarians. It is about what kind of role the visual arts are to play in our culture and, by extension, what role culture is to play in our society. It is nothing less than a debate about one of the fundamentals of democracy.

The notion that museums should somehow pay for themselves (either by charging visitors or by way of private and corporate sponsorship) has long been commonplace in the United States. This was, in part, a logical extension of the concept of private individuals taking responsibility, a characteristic of the North American museum landscape from its inception. The idea is relatively novel as far as European institutions are concerned. It was first propagated in the United Kingdom, without subtlety and to dreadful effect, under the Thatcher government in the 1980s. Elsewhere in Europe, though this shift seems increasingly inevitable, it is still met with widespread professional and political resistance. If, initially, this change seemed to entail no more than a switch of paymaster (from public to private), it has since become obvious that it has had profound effects on the outlook and ethos of museums. It is generally agreed that a historic tipping point has been reached,[170] though not all would concur with the art critic David Carrier's recent claim that we are seeing 'the end of the modern public art museum'.[171]

In the past, the concept of the museum arose from the principle of making an elite culture available to all, in order to educate to the highest possible standard and provide the greatest enjoyment. This model of the museum emerged from much the same Enlightenment mould as notions of democracy and education. The idea of the museum as egalitarian enabler has never lost its allure; and elitism for all, a notion of glorious and radical ambition, simultaneously naïve and highly potent, steered the museum for the better part of 200 years. By and large, the balance between utopian dream and everyday reality held remarkably well.

Today, it seems that curators have lost faith in the democratising power of the institution and that these revolutionary ideas no longer hold any appeal. Museums have forgotten their revolutionary origins and their extraordinary history. In the new

170
The most spirited recent defence of the museum is contained in a series of lectures given by, among others, Philippe de Montebello, Glenn D. Lowry and Neil MacGregor, reprinted in James Cuno (ed), *Whose Muse? Art Museums and Public Trust* (Princeton and Oxford: Princeton University Press, 2004).

171
See: David Carrier, *Museum Skepticism. A History of the Display of Art in Public Galleries* (Durham and London: Duke University Press, 2006), pp 181–207.

museum, the individual visitor is no longer considered, and no credence is given to the idea of elite culture being offered to all. The new museum has no time for such delicate complexities. In its fixation on numbers (box office or, to use the language of retail, 'footfall'), together with its fear of either underestimating or overestimating the audience's capacity to understand, the new museum has sidelined its old utopian ideals, which are now deemed to be pitfalls. In the process, art for all has given way to the 'democracy of spectacle': an ambition to be attractive to the greatest number of people at all costs. This has become the new museum's blanket justification and its strongest defence.

If mass appeal is the best defence apologists for the new museum can muster, it is also the crudest. It is crude because it can be used to parry any sort of criticism, above all the dreaded charge of elitism. It deliberately muddles the issues (above all, the distinction between elite culture for all and culture for an elite) and closes off any discourse about the nature of the fundamental changes that the new museum proposes. As for the mass appeal of the new museum, it is a questionable argument for its validity. As the philosopher Theodor Adorno has observed, 'the culture industry piously claims to be guided by its customers and to supply them what they ask for [...] The culture industry not so much adapts to the reactions of its customers as it counterfeits them.' [172] Adorno was referring primarily to the film industry, but his observation also holds true for the new museum. By turning itself into another branch of the culture industry, the new museum has not just suspended its old guiding principles but has, as we shall see, turned them upside down. It has, in the process, let go of its historical roots and its intellectual purpose. Shifting the emphasis from education to entertainment, it has changed the ground rules – only without, alas, alerting its visitors. By this sleight of hand, the old museum's politicised citizen and visitor has become the new museum's passive consumer, simultaneously manipulated, disempowered and infantilised.

Rosalind Krauss was the first to observe this new trend in her celebrated essay 'The Logic of the Late Capitalist Museum' (1990). She spelled out its consequences presciently: the new museum would 'forgo history in the name of a kind of intensity of experience, an aesthetic that is not so much temporal (historical) as it is

172
Adorno, Theodor. *Minima Moralia: Reflections on a Damaged Life,* (London and New York: Verso, 2006) p 200.

now radically spatial'.[173] This goal would be achieved by reversing all the guiding and defining principles of the old museum. Quantity would supersede quality. Diffusion would displace concentration. Chronology would be replaced by revival, memory by amnesia, authenticity by copy, order by chaos. Instead of focus there would be distraction and history would be sacrificed for novelty. In lieu of preservation there would be disposal, and sensation and spectacle would take the place of contemplation and experience.

For Krauss, the artistic model for this shift was Minimalism or, more precisely, the 'articulated spatial presence specific to Minimalism'.[174] Viewing an exhibition of works from the Panza Collection at the Musée d'Art moderne de la Ville de Paris in 1983, Krauss observed that, more than the art on display,

> it is the museum that emerges as [a] powerful presence and yet as properly empty, the museum as a space from which the collection has withdrawn. For indeed the effect of this experience is to render it impossible to look at the paintings hanging in those few galleries still displaying the permanent collection. Compared to the scale of Minimalist works, the earlier paintings and sculpture look impossibly tiny and inconsequential, like postcards, and the gallery's take on a fussy, crowded, culturally irrelevant look, like so many curio shops.[175]

The implication of Minimalism here has since become something of a critical cliché and I will discuss the validity and limits of this line of argument later. For Krauss, the new museum had substituted the erstwhile experience of the viewer, *contemplative and framed by personal knowledge*: 'In place of the older emotions there is now an experience that must properly be termed an "intensity" – a free-floating and impersonal feeling dominated by a peculiar euphoria.'[176] In other words, the museum offers an experience akin to a visit to a department store. Krauss had no doubts about the ultimate outcome of this gradual shift. In her view, the 'industrialised museum will have much more in common with other industrialised areas of leisure – Disneyland, say – than it will with the older, pre-industrial museum. Thus it will be dealing with mass markets, rather than art markets, and with simulacra experience rather than aesthetic immediacy.'[177]

173
Rosalind Krauss, 'The Logic of the Late Capitalist Museum', in: Claire J Farago and Donald Preziosi (eds), *Grasping the World: The Idea of The Museum* (Aldershot: Ashgate, 2004) p 604.

174
Krauss, op.cit., p 601.

175
Krauss, op.cit., p 602.

176
Krauss, op.cit., p 610.

177
Krauss, op.cit., pp 611–612.

178
That this should occur at a time, post-1989, when the capitalist free market model became ubiquitous, is no coincidence.

Unexpectedly, given
its historic policy of
disengagement from
globalisation, France has
emerged in the vanguard
of European countries
implementing the 'Krens
doctrine'. Both the Louvre
and the Centre Pompidou
are due shortly to open
antennes within France
and both institutions have
recently engaged in plans to
operate Guggenheim-style
franchises abroad. Thus
far, the Pompidou's hopes
of gaining a foothold in
Asia have suffered several
setbacks, though
negotiations to open a
satellite museum in
Shanghai are ongoing.
In 2005 the Louvre entered
a three-year collaboration
with the High Museum
of Art, Atlanta, lending
the museum (in which the
Louvre now occupies its
own wing) some of its most
prized treasures in return
for a fee of Euro 13 million.
And in 2007 the French
government signed a
contract with the United
Arab Emirates whereby, for
fees totaling over 1 billion,
the Louvre's name, its
curators' expertise and
works from its collection
and those of other French
museums will be loaned
to a museum to be built in
the oil-rich emirate of Abu
Dhabi, as the centrepiece
(alongside, inevitably,
a proposed Guggenheim
museum) of a major tourist
development on Saadiyat
Island. The scheme has
been attacked by many
senior figures in the French
museum world; see:
Editorial, 'A Desert Folly',
The Burlington Magazine,
May 2007, p 295.

When Krauss wrote her essay the trends she described were only beginning to emerge and, to many observers at the time, her conclusions seemed unduly alarmist and wildly exaggerated. In fact, reality far surpassed even her darkest predictions. The concept of the late capitalist museum has since been implemented step by step, with astonishing rapidity and against little critical resistance, suggesting it was the only outcome historically possible.[178] To begin with, this trend was contained largely within the Guggenheim Museum in New York and its various international satellite projects. Thomas Krens, the Guggenheim's director from 1988 to 2008, became the poster boy of the new museum, its most outspoken defender and ardent practitioner. Before long his model gained wide currency. Today, many museums all over the world are run, if not in name at least in spirit, according to what might be termed the 'Krens doctrine'.

That the new museum should seek its salvation in commerce highlights an historical paradox, for the idea of the museum as a non-commercial sphere was programmatic from its inception. For the founders of most nineteenth century museums in the English-speaking world, they were the anti-realm of their own commercial activities, a place where money could transmutate into something higher. The museum's unprecedented authority in cultural matters was the result of this particular division. In complete reversal of this reality, the 'Krens doctrine' is an attempt to square the circle, to turn the museum into a cultural industry without surrendering its authority and to commercialise it without jeopardising its special status. Although several of Krens's most ambitious projects have failed to materialise – proposals for Guggenheim franchises in Taiwan, Rio de Janeiro and Mexico have all been shelved – his doctrine has nonetheless become a powerful dogma, embraced, to varying degrees, by museums the world over.[179] Like all powerful dogmas, it is rarely questioned and never fully explained. For a whole generation of museum directors and curators, it has become the sole guarantor of institutional survival and legitimacy. While some adherents go so far as to say that museums are nothing but specialist businesses active in the field of high culture, others talk more delicately about the need to run their institutions in a business-like fashion.

There is no denying that, for a while, this new approach brought spectacular results: museums were the great cultural success story of the late twentieth century. New ones opened seemingly every month; old ones were expanded or reconfigured. Audiences grew, collections were built, and major exhibitions circulated to an ever widening range of venues. Museums became the new civic status symbols, much as theatres and opera houses had been in the immediate post-War period.

But this approach has not proved the panacea its promoters imagined. What seemed at first an effective medicine has begun to reveal some troubling side effects. These can best be summarised as the creation of moral and ethical ambiguities that had hitherto been absent from the museum sphere. The inherent contradiction at the centre of the 'Krens doctrine', the conflict between corporate ambition and cultural status, has not yet been resolved. Increasingly, it seems that it never will be. The majority of museum officials (directors, curators, trustees) remain in denial, but the chorus of discontent grows ever louder.[180]

It is a hallmark of late capitalism that capital and power have been rendered strangely invisible – that is to say, their presence is undeniable, but their source is obscured and their directional flow hard to chart. A corporation wields power, yet how it is constituted and from where it emanates is difficult to pinpoint. The same holds true of the museum in its new cultural-industry incarnation. A myriad group of contributors make up the institution's power. From within, there are the director, chief executive, trustees, curators and those responsible for marketing and public relations. From outside, architects, artists, consultants and guest curators are called upon to reinforce the institutional message. From time to time, politicians and sponsors choose to interfere. This no longer amounts to a classic power pyramid; and it would be futile to attempt to describe or analyse the institutional structure as such. How decisions are arrived at and how they are finally implemented – the what, why, where and when of this process – have all been rendered opaque and, as a result, the new museum, like its corporate model, has become strangely unaccountable for its actions. Within an institution, contributors to this intricate web of power and influence hide behind one another. Decisions are described as 'collective', even when they are not.

180
See: Cuno (ed), op. cit.

When things go awry, blame for 'bad' decisions is instinctively placed with others, preferably outside the institution: mimicking corporations, the new museum likes to cite market forces, political circumstances and changing times (shifting markets, global trends, competition) as the trigger for its actions, in the process giving them an almost Biblical inevitability that is safely beyond review or criticism.

Ultimately, it is irrelevant how decisions are arrived at or who drives and implements them. For the sake of the present argument, it is sufficient to look at the results. What has the late-capitalist museum, post-Krauss and post-Krens, become? What are its hallmarks? What are its particular qualities and weaknesses? I will focus my analysis on the three areas where almost all museum activity is now concentrated: architecture, permanent collections and temporary exhibitions and displays. How have the politics and demands of the new museum affected architecture, collecting policies and exhibition-making? How has the desire to attract large audiences impinged on these core areas? How has the escalating need for non-public income (sponsorship and box office) shaped museum agendas? What are the positive and the negative results of the paradigmatic shift set in motion over the last two decades? What bearing have these changes had on the museum's standing in the wider cultural and political context? And how will all this determine our future understanding of and attitude to museums?

Architecture

Architecture and location have always been the visible calling cards of the museum. They are a public statement of its cultural ambition. A prominent geographical location marks the museum's exalted civic status, its central place in the fabric of a city in particular and of a nation in general. By locating the national museum in the former royal palace, the French revolutionaries in 1792 set a precedent that has been followed ever since: the choice of place signified both the exceptional status and the centrality of the new institution in national discourse. If the choice of location remained important, so did the choice of architectural

language. The exterior of the building prepared the visitor for what to expect inside. Architecture left no doubt about what the museum was about, articulating the cultural hierarchy upheld within. Consequently, variations on classical models remained a hallmark of museum architecture well into the twentieth century. Even high-modernist buildings, such as Mies van der Rohe's Neue Nationalgalerie in Berlin (1965–1968), were loaded with classical references. This remained the rule, more-or-less, for nearly two centuries.

However, something strange seems to have happened to museum architecture over the last two decades: buildings have become autonomous, by severing the link, first, between exterior and interior and, secondly and even more problematically, between interior and content. It is tempting to place Frank Gehry's Guggenheim Museum in Bilbao (1993–1997) at the beginning of this trajectory; but, with hindsight, the Neue Pinakothek in Munich (1977–1981) and James Stirling's Staatsgalerie in Stuttgart (1981–1984) are the true precursors, their conceptual radicalism masked by nineteenth century references (to Schinkel's 1825–1828 Alte Museum in Berlin in particular). In this respect, Stirling's well-known quip at the opening of the Staatsgalerie that it would have looked better without art, was prescient. Since then, architects have increasingly taken liberties and created buildings that pay less and less attention to the requirements of art and artists. Gradually, museum architecture has emancipated itself from its function. If, in Bilbao, Gehry made at least half-hearted concessions to the needs of the museum and shoe-horned, albeit uncomfortably, relatively conventional galleries into the folds of his baroque exterior, more recent architects seem to be no longer willing to make even such basic allowances. Daniel Liebeskind's Jewish Museum in Berlin (1997–1999) is a building that has been much complimented for its eloquent symbolism, but this held true only as long as the museum remained empty. Once the curators installed their exhibits, the interiors became a claustrophobic, cluttered mess: content and envelope were aggressively at odds.[181]

The result is not always as disastrous, and in the majority of cases the mismatch is merely irritating. At Tate Modern (1996–2000), Herzog and de Meuron's curious lack of willingness to consider the

181
The same happened more recently in San Francisco at the new De Young Museum (by Herzog and de Meuron, opened 2005).

basic requirements of the museum continues to interfere with the art on display. Their insistence on installing fluorescent lighting has been one of the most frequently discussed faults of the building, as has their insistence (against all professional advice) of laying raw oak flooring that was to acquire a patina through use over time. The result is an interior that looks forever gloomy and grubby. Another example of this disregard for function is Tadao Ando's Fort Worth Art Museum (1999–2002), a building so severely modernist that works of art within it merely play a supporting role. In the opening displays, a Warhol self-portrait at the top of the main staircase appeared like ornamentation – a detail – the sole purpose of which, it seemed, was to throw the architecture into higher relief. More recently, Zaha Hadid's Museum of Contemporary Art in Rome (begun in 2005) is a building that seems to have been commissioned with no other brief in mind than the creation of a landmark, a museum without collection, exhibition programme or declared purpose.[182] The exterior has finally taken over at the expense of all else. If anything, this trend has accelerated over recent years: a recent traveling exhibition 'Museums in the 21st Century: Concepts, Projects, Buildings' documented about two dozen current projects (including Hadid's Rome museum), every one of unprecedented theatricality, as if an entire generation of architects was suddenly inspired solely by German Expressionist cinema.[183] Centrifugal, exploding, expanding, dynamic, throbbing, pulsating, pivoting, sculptural, operatic, delirious, high-octane, futuristic, narcissistic – this is only a small catalogue of the adjectives useful in describing the latest crop of museum projects. These are buildings in which art plays a secondary part and, at the most extreme, is done away with altogether. For example, in the Museum of the Hellenic Word in Asia Minor, in Athens (currently under construction), Anamorphosis Architects 'translate the context to be depicted – the history of Hellenistic Asia Minor, from beginnings to the present day – into spatial experience, or, as they themselves call it, a three-dimensional monument'.[184] Their 'anti-object concept of exhibitions is, in the first place, *a criticism of the collecting and purchasing activities of museums* […] Secondly it is a criticism of architecture that mutates into an advertising medium.'[185] A new generation of architects, it seems, has appropriated Krauss's critique and adopted it as their credo.

[182]
The result will no doubt replicate what happened in Barcelona with Richard Meier's Museum of Contemporary Art, a museum forever in search of an identity and mission.

[183]
See: Suzabbe Greub and Thierry Greub, *Museums in the 21st Century: Concepts, Projects, Buildings* [exhibition catalogue] (Munich, Berlin, London and New York: Prestel, 2006) pp 138–139.

[184]
Greub and Greub (eds), *op.cit.*, p 138.

[185]
Greub and Greub (eds), *op.cit.*, p 138.

By and large, architects' accelerating claims to autonomy as far as the function of museums is concerned have gone unchallenged. One reason is, perhaps, that a museum's quest for funding is made much easier by presenting funders (public or private) with an emblematic landmark building. In this equation, conventional functionality is of little concern.

As for the dozen or so books on recent museum architecture, they too note the divergence between form and function only in passing. They are, without exception, authored by architectural historians or architecture critics and thus written from the architect's perspective. They comment on the emancipation of museum architecture from function but do not take issue with it. It is also noticeable that the majority of illustrations in these publications show buildings empty, devoid of art or visitors. To my knowledge, no museum director or curator has gone on record to criticise this disturbing development in museum architecture, recalling the fraught relationship between architect and client satirised by Tom Wolfe in *From Bauhaus to our House*.[186] Instead, curators muddle through at great cost and effort with buildings barely suitable for the function they were supposedly designed to accommodate.

The choice of architectural language, or the disconnection of form and function, is not the only problem; it is also the scale of many museums that brings buildings into conflict with the art on display. The most notorious example is the Turbine Hall at Tate Modern, a space that, as a matter of course, dwarfs any work of art shown within it, presenting artists with a challenge that they have rarely met successfully. The same holds true for the huge central atrium and the enormous gallery devoted to contemporary art in Yoshio Taniguchi's new Museum of Modern Art in New York (1995–2003) or the oversize special exhibition hall at the Guggenheim Museum in Bilbao.[187] The gigantic museum not only makes the art on display look unimportant, as Krauss observed, but it also leaves the visitor dissatisfied, lost in a labyrinth and unable to take it all in. (It is no coincidence that small, intimate museums remain so loved by the public).

As yet, no lessons have been learned from all of this. Tate Modern's proposed glass ziggurat South Tower (also by Herzog and de Meuron) seems to combine the worst of these twin

186
London: Jonathan Cape, 1982.

187
This was a battle in which the Guggenheim's curators finally conceded defeat. The hall is now filled with a large group of sculptures by Richard Serra, on display for an initial term of twenty-five years.

trends, excessive theatricality and gargantuan scale.[188] It is yet another stark example of the architectural narcissism now prevalent, another massive site-specific sculpture that will dominate and interfere with the scale of an existing building and dwarf both art and visitor.

It may appear some form of poetic justice that this new type of museum architecture as spectacle rises and falls by the same principle – the rule of its own inflationary aesthetic: one Guggenheim Bilbao may be exhilarating, a succession of clones is boring. As hyper-expressionist buildings have become the norm, they no longer register as exceptional landmarks but merely as predictable signifiers of a museum. Their originality has quickly turned banal. Their dysfunctional theatricality has become a debased currency, no longer able to sustain interest for long. The architecture is literally consumed by the onlooker, to be discarded as casually as last season's fashion accessory or the latest must-have technological gizmo. That, a mere six years after opening, Tate Modern felt it necessary to commission a landmark addition, gives a measure of this acceleration.

Financial circumstances permitting, it is easy to conceive of a future where museum buildings might be erected as temporary pavilions, ongoing displays of avant-garde architecture, raised up and torn down without much ado, with all institutional energy and care forever focused on the skin. That many of the new buildings seem to be conservation time-bombs may only reinforce such a trend: so technologically advanced and complex has contemporary architecture become, that long-term maintenance may no longer be a feasible option.

Exhibiting

If the democracy of spectacle favours an architecture that is theatrical and that turns the museum into a *locus per se*, a venue that is visited and experienced for its own sake, the way in which works are exhibited and the choice of what is displayed follows a similar logic.

Up until the late 1970s, while the permanent collection retained centre stage, temporary exhibitions were a comparatively

188
Since writing the plans have been heavily revised, the building is now brick clad.

rare occurrence in museums. This hierarchy has not only been gradually reversed, but has almost entirely dissolved: while temporary exhibitions have become the lifeblood of museums, permanent displays have become temporary, endlessly changing and evolving. It should follow that a much wider range of exhibits is shown, a broader canon is explored and a greater proportion of the museum's holdings is put on display, even if only in rotation. Yet oddly, this temporalisation of the museum has created the opposite effect: although the number of museums (and other exhibition venues) has grown exponentially, the canon of what is on view (both in temporary exhibitions or semi-permanent displays) has stagnated, if not actually shrunk. The need for box-office success has ensured this. It has made museums, as far as their display and exhibition policies are concerned, entirely risk-averse. Not only are curators no longer willing to take chances in their displays and exhibition programmes, they can no longer afford to do so. In their new expansionist and success-driven incarnation, like their counterparts in the film and publishing industries, museums have come to rely on the tried and tested. To do otherwise would be to commit commercial suicide. Just as the film industry counts on sequels to guarantee a box-office hit, and publishing conglomerates focus on bestsellers at the expense of more challenging literature, the risk-averse new museum, now a self-declared part of the cultural industry, focuses relentlessly on the iconic, the already famous, the perennial favourites: Impressionism, Post-Impressionism, the great artists of the twentieth century. Playing to the gallery, it favours an art that is literal (anything figurative), emotional (emotion is easier to appeal to than the intellect), issue-driven (yet never radically political). It champions whenever possible an art where autobiography and work are inextricably linked (Caravaggio, Van Gogh, Modigliani, Frida Kahlo, Diane Arbus, Tracey Emin). The new museum's media of choice are film, video and photography, easy to comprehend, easy to install and in many cases requiring only the most superficial engagement from the viewer. Video and film can turn entire enfilades of galleries into virtual multiplexes. The new museum prefers installations to single works, because it likes its visitor engulfed, caught up in the theatrics on offer, enraptured and overcome by spectacle.

For obvious reasons, exhibitions dedicated to fashion have become more frequent. If fashion signals the ultimate in consumer disengagement – its rationale no more than theatre and entertainment – its arrival in the new museum makes perfect sense: fashion's agenda of recasting content as style, re-inventing art object as ornamental back-drop and reducing history to a mere source for periodical revivals, meshes neatly with the new museum's own anti-historical inclinations and its goal to reposition art as entertainment. Conceptually and intellectually, the new breed of fashion exhibition takes the museum closer to *Hello!* than, say, *October* magazine. In place of critical distance – analysis of how fashion works, how it is arrived at and how it is disseminated – the new museum is content merely to capture or replicate fashion's theatricality. It suspends curatorial judgment and offers in its place something approximating to the spectacle and immediacy of an actual fashion moment. In this respect, fashion exhibitions have become hard-core. In 2005, the Metropolitan Museum of Art in New York staged the exhibition 'Anglomania', a meaningless romp through 200 years of British fashion.[189] Set in the museum's English period rooms against the backdrop of one of the world's greatest collections of English furniture, each room offered a different tableaux ('the gentlemen's club', 'the English garden', 'upstairs/downstairs'), mixing historic and contemporary clothing. The effect was one of de-historicisation, an intentional blurring of the line between original and copy, where the past was reduced to an open-ended resource for style choices and where questions of authenticity no longer mattered – Orwellian curating. A year later, the Museum of Fine Arts in Boston mounted 'Fashion Show'.[190] Focusing on the clothes from the current couture collections of nine Parisian fashion houses, the display consisted of mannequins dressed by each of the nine designers accompanied by the respective house's most recent promotional video. Nowhere near approaching the glamorous pitch of 'Anglomania', the exhibition was deeply disappointing to view, and turned out to be a box-office flop. Concurrent with this, the Metropolitan Museum opened 'Nan Kempner: American Chic' to show off the late socialite's stupendous couture wardrobe.[191] On the other side of the Atlantic, the Victoria & Albert Museum followed suit with 'Kylie Minogue:

[189]
'Anglomania',
Metropolitan Museum of
Art, New York (May 3 to
September 4, 2006).

[190]
'Fashion Show: Paris
Collections 2006',
Museum of Fine Arts,
Boston (November 12,
2006, to March 18, 2007).

[191]
'Nan Kempner: American
Chic', Metropolitan
Museum of Art, New York
(December 12, 2006, to
March 4, 2007).

The Exhibition'.[192] Defending the show, a museum spokesperson half-heartedly declared that 'We hope this exhibition will attract students of fashion and stage costume design', while the academic Lisa Jardine (a trustee of the V&A), in a let-them-eat-cake moment, affirmed that 'It is certainly not our job to be elitist'.[193]

To accommodate the new museum's need for undemanding aesthetic spectacle, art history has had to be selectively re-written. In the case of Picasso, for example, the critical discourse of the last twenty years or so has largely focused on the biography-work dichotomy, as if his stylistic evolution were entirely prompted by changing personal circumstances, in place of a more formalist analysis of his *œuvre* – a bias reflected in numerous recent museum exhibitions dedicated to the artist. Meanwhile, Krauss's implication of Minimalism in the formation and politics of the new museum has been taken up by Hal Foster in his alarmingly entitled essay 'Dan Flavin and the Catastrophe of Minimalism'.[194] Foster appears to blame Flavin for a subsequent misinterpretation of Minimalism, which is about as reasonable as holding Mies van der Rohe responsible for every glass box erected since the opening of the Seagram Building. But both Krauss and Foster concede that it is in the rewriting of the history of Minimalism that the problem lies: an intentional misreading of the historic record by shifting the focus from the centre of the movement to the margins, where an art whose nature fits better with the requirements of the new museum is sited.

This shift may be illustrated by comparing the work of Flavin and James Turrell. Flavin's is an art of controlled rationality. The effect of his work (however beautiful or theatrical it may be) is counterbalanced by the open display of its source (the 'specific object'). Flavin's aim is to set up a dialectic between the specific object and the theatrical potential that is invoked, revoked and invoked again, *ad infinitum*. The theatrical potential upon which he touches is at its extreme a directionless emotional blurring, surpassing the realm of beauty and quickly entering, without warning, a zone of emotion evoked for its own sake; in short – kitsch – a faux spirituality, religiosity without religion, affect without object. Flavin is effectively playing with fire, but he does so consciously and, above all, he makes the viewer not only aware of his intention but participatory in the dialectic he has

192
'Kylie Minogue: The Exhibition', Victoria and Albert Museum, London, (February 8 to June 10, 2007).

193
Quoted in: Vanessa Thorpe, 'V & A Under Fire Over Kylie Show', *The Observer*, February 4, 2007, p 18.

194
In: Jeffrey Weiss (ed), *Dan Flavin: New Light* [exhibition catalogue] (New Haven, London and Washington DC: Yale University Press and National Gallery of Art, 2006), pp 133–151.

set up. This 'reality check' does not occur in the work of Turrell. What this artist offers is the opposite: his is an art of old-fashioned illusionism. It is an art of effect that is entirely focused on the theatrical potential, its source rendered invisible. In lieu of Flavin's modernist rationality, Turrell presents the open-ended illusion of a synthetic spirituality and *ersatz* mysticism, a profusion without profundity, the illusion of emotion in place of true feeling and engagement. His elevated place in the pantheon of the new museum may be entirely at odds with his actual historic contribution, but it is commensurate with the important role he plays within the institution: he provides a fail-safe ride for the new museum theme park, easy on the mind and easy on the eye, visually compelling, all-engulfing and theatrical.

Another artist who has come to prominence in the new museum is Bill Viola. Liberally quoting Old Master references, Viola empties his religious subject matter of all meaning and recasts it as *objet de luxe*, the ultimate consumer object. His theatre of emotion finds its match in a hysterical viewer: when spectators cry on viewing his work, as they often do, they really only weep at their own tears. Conceived on a grand scale to the highest production standards, Viola's art is the video version of high-Victorian painting. If Turrell provides the new-age ride to the museum, Viola contributes its spiritual equivalent, a hollow emotion that is in the end undemanding, empty and disengaged.

The greatest difference between Flavin, on one hand, and Turrell and Viola, on the other, is where they leave their viewers. Flavin empowers his, makes them active participants in the constitution of the work. His audience is in charge and fully conscious, whereas Turrell's and Viola's viewers are disempowered, overwhelmed and emotionally manipulated. Running between active participant and passive consumer, this is exactly the same fault line that divides the old and the new museum.

Collecting

In the old museum, the collection was the main focus of curatorial attention, a permanent fixture towards which scholarship, research and acquisition policies were directed. The collection's

content and particular shape, its eccentricities, strengths and weaknesses, set the terms of reference for all the museum's other activities. Conceptually, permanent displays and the collection were perceived as one and the same. This is not the case in the new museum. Displays have gone from static to forever changing, to such a degree that they increasingly resemble temporary exhibitions. This obviously affects the way in which curators view the collections in their charge. For a new generation of curators, collections need to be constantly refreshed and are perceived merely as a resource, a pool from which temporary displays can endlessly be drawn and loans to other institutions granted, but no longer as an entity that adds up to more than the sum of its parts. This conceptual dematerialisation of the collection has become one of the hallmarks of the new museum. Since the collection is no longer thought of as an entity, it can no longer help set the points of reference for acquisition decisions. As a result, purchases have inevitably become random, either dictated almost exclusively by personal taste and inclination or, at the other extreme, fashion- and market-driven. As time goes by, the collection as a resource becomes a self-fulfilling prophecy: the long-term outcome is not a collection but a heterogeneous assemblage of objects.

When a museum's collection is no longer seen as an organic entity with a particular character and a history of its own, de-accessioning is the next logical step. Adopting euphemistic management speak (indicating at least a trace of shame about what it is proposing), the new museum justifies its actions by claiming that it is only 're-focusing its activities', 'rationalising its collecting activities', 'diversifying', 'maximising its assets' or 'strengthening its core mission'. ('Core mission' is a favourite buzz-word in new-museum speak.) The benefit to the long-term interest of the institution is always invoked. The deceptive simplicity and rationale of this language barely manages to hide the fact that, under its cover, acts of cultural vandalism are being performed against both the fabric and history of institutions. Not only do objects disappear, but institutional memory is erased into the bargain.

In recent years, de-accessioning has become more prevalent. In Europe, where the subject used to be taboo, it is now openly discussed by curators and politicians. In America, the practice

is no longer restricted to minor examples or duplicates from the print room, but is extended to major works of which any museum might be envious. In 2003, for example, the Museum of Modern Art sold three highly important paintings by Modigliani, Picasso and Pollock, in the process raising over $50 million. More recently, the Albright-Knox Art Gallery's decision to divest itself of a group of major works from its small historic collection in order to establish a contemporary art endowment fund, drew particularly harsh criticism. [195] It was not only the quality of the works consigned for sale that caused disquiet. Sotheby's (appointed to handle the sales) described the de-accessioned *Granite Figure of Shiva as Brahma* (tenth–eleventh century) as 'without question the greatest Indian sculpture ever to appear on the market', and the Roman bronze *Artemis and the Stag* (first century BC/AD) as 'among the very finest large classical bronze sculptures in America'.[196] The idea that a museum was providing the market with such gems and that these works would inevitably end up in private hands – that *de facto* the privatisation of public cultural assets was taking place – struck many observers as deeply troubling. That this was done in order to purchase contemporary art did not help matters: was the museum not in fact entering an already overcrowded niche market with too little cash, too late? Significant works by the most coveted contemporary artists are rarely available, fiercely fought over and often very expensive.

If the de-accessioning trend continues, it will have major repercussions for the future of museum collections. Ultimately, it will debase the concept of perpetual public ownership – the main justification for generous tax concessions in the United States and public and charitable grants in Europe. These concessions will obviously become vulnerable to scrutiny. If de-accessioning evolves into an acceptable practice, it will lay museums open to politically motivated raids of their collections, as happened for the first time in the UK in 2006 when Bury Metropolitan Council sold at auction for £1.1 million a painting by L.S. Lowry from the collection of Bury Art Gallery and Museum in order to balance the council budget. Such actions will inevitably deter donors from giving their works to museums since the future fate of their gifts is no longer guaranteed, however exceptional their quality. It will also make museums susceptible to many more

195
See, for instance: Tom L. Freudenheim, 'Shuffled Off in Buffalo', *Wall Street Journal*, November 15, 2006; and Christopher Knight, 'Cashing in or Selling Out?', *Los Angeles Times*, January 14, 2007.

196
Sotheby's press release, November 10, 2006. *Artemis and the Stag* sold the following June for $25.5 million, the highest price ever paid at auction for a sculpture.

restitution claims by nation states, since the present defence of perpetual public ownership for the public good could no longer reasonably be invoked.[197]

Ambivalence about the museum on the part of curators, visitors, artists and politicians is not a new phenomenon. The history of museums demonstrates that each constituent group has, at various times, raised different objections and expressed all kinds of dissatisfaction and doubts about the systems in place. The difference now is that the disquiet the new museum is causing is almost universal. What is worrying is that, in the end, every participant in the new museum feels short-changed, frustrated or disappointed. By the measure of its own standards and declared intentions, the new museum has not lived up to its promise. Having recast the visitor as a consumer, it has elicited the response of a consumer: never satisfied and always on the lookout for more. However much visitors may be attracted to the spectacle of the new museum and however much they may be conditioned by it, they still expect the museum to deliver all the qualities of the old museum as well. They continue to believe in the institutional superiority, impartiality and the guarantee of the highest quality. In the visitor's mind the museum is still synonymous with an educational mission of high culture. Visitors still have absolute trust in the museum's integrity and its ability to deliver. And their disappointment is twofold: they are dissatisfied that the spectacle on offer – exhibitions, architecture, services – is not bigger, more theatrical, more spectacular; and they are disillusioned that their trust in the institution has been betrayed – they are beset by the nagging suspicion that they have been offered sub-standard fare.

Curators are also unhappy with their role. Their curatorial independence has gradually been eroded. They are no longer the specialist scholar-curators of the past, who stood at the centre of the institution. In the new museum, they find themselves at the nexus of an exhibition industry in which their role is reduced to administrator and where exhibitions do not benefit from their scholarship but are staged from purely financial motives. The curator's mandate is now to provide, above all, commercially viable entertainment. As for choices of exhibitions and displays, these are no longer exclusively the curator's, but are dictated by

197
Private restitution claims have already become much more frequent, actively supported by specialist lawyers and supply-starved auction houses.

commercial imperatives and institutional politics. There is no room any more for the curious, the neglected, the adventurous, the eccentric; no place for the untried or untested. Most worryingly, there is no room for scholarship. There is no call for it either, because scholarship, by the logic of the new museum, does not serve an identifiable purpose – it does not contribute to the financial bottom line. As a result, art history has retreated from the museum to the university. For the first time, the vast majority of new art-historical research is now taking place outside museums.[198]

Artists' attitudes towards the museum have also grown more ambivalent. In the past, artists could rely on a life-long support stream, with input from various interested parties at different points in their career – support from adventurous young dealers and collectors at the outset, followed by exhibition invitations from small museums and Kunsthalles, then interest from blue-chip collectors, big museums, secondary-market dealers and auction houses, and finally the offer of a retrospective in a major institution. This trajectory gave artists the time and means to develop their ideas. Today, all interest groups fish in the same pond simultaneously, creating instant market bubbles and hysteria wherever the attention turns. After 2002, for example, photography became ubiquitous for two or three seasons, to be abruptly replaced, first by New German painting, then by contemporary Chinese art. The pressure on artists to seize the moment and serve these demands has never been greater.

When an artist's work is put on display in the new museum, it is subsumed by the general theatre of the venue, interpreted, branded and homogenised. Artwork is no longer considered on its own merit, but becomes a variable in the overall equation of the democracy of spectacle. It is not read in isolation but as part of a chain of stimuli selected and calibrated to keep the client-visitor amused; the artist's autonomy is sacrificed to the institution's overreaching corporate ambition. In this scenario, the museum has lost the privileged place it held for artists as an intellectual sanctuary, where their rights were protected and their wishes respected above all else. The new museum no longer constitutes a special, safe realm but is part of an encroaching and all-consuming malaise: on one hand the market place, where artists' work is

198
The relationship between these two branches of art history is explored in: Charles W. Haxthausen (ed), *The Two Art Histories: The Museum and the University* (London and New Haven: Yale University Press, 2002).

literally consumed, on the other hand, the museum, where the consumption is metaphorical, where their art is offered as diversion and entertainment. Carsten Höller seemed to have been commenting ironically on this development in his Turbine Hall commission at Tate Modern in 2006, when he filled the space with a series of slides. An irresistible attraction for tens of thousands of screaming children, the slides promptly swept Tate Modern to the top of that year's UK museum attendance table. Yet, in the end, Höller merely highlighted a dilemma without suggesting a solution to it, and one suspects that his installation may have been less critique than resigned collaboration. In the new museum, the artist finds himself reduced to mere content provider, a handmaiden to corporate dreams. The artist's role, previously at the centre of the museum, has become, like everyone else's, marginal.

Over time, the new museum has manoeuvred itself into a precarious position. It has adopted the circular, inescapable logic of the corporate market place with its overreaching fixation on expansion, competition and growth, a logic that has quickly come to over-rule every other institutional consideration. It has bred a generation of visitors who are, as far as their entertainment expectations are concerned, endlessly demanding. New buildings, major exhibitions, forever expanding services, all pander to these expectations at an ever-escalating cost. Yet, however much the museum likes to see itself as a corporate entity, in reality it is not. Unlike big business, museums cannot tap into the capital markets to finance their capital projects and they cannot borrow to deal with temporary shortfalls or unforeseen reversals. Most cannot even run a deficit legally. There is no mechanism for the deferment of financial pressures by means of taking out overdrafts or issuing bonds. Unlike corporations, museums do not run reserves; they are zero-sum businesses – that is to say, income is immediately spent (this is why museums can sincerely claim to be perennially under-funded, irrespective of how successful they are). There is no room for error, and thus the pressure to attract huge crowds (if not paying then at least spending) is so relentless that it over-rides all other considerations. The precariousness

of the situation became clear a few months after the terrorist attacks on September 11, 2001, when museums on both sides of the Atlantic faced major financial difficulties following a steep drop in tourism.[199] Fortunately, the downturn did not last long, but it was an unwelcome reminder of how vulnerable most institutions have become.

The reliance on large attendance figures, combined with an expansive mindset, has created its own irrefutable logic: in order to survive, the new museum has to keep expanding. This self-justifying logic is flawless and is the reason why politicians are so weary of museums' incessant demands for funding: they are by nature open-ended and limitless.

To meet these financial demands, the new museum acts more and more like a business and less and less like a museum. Fundraising activities become increasingly aggressive, no commercial opportunity is left unturned, no ruse to earn money passed up. In the process, museums are moving further and further away from the ideals of their past. A blind eye is turned to the agenda of those signing the cheques. Ann Drew, Head of Sponsorship at UBS for Europe, the Middle East and Africa, recently explained the bank's involvement in art sponsorship as follows: 'We have a number of different deliverables around our sponsorship investments: to create brand awareness, favourable opportunities for client entertaining and networking and, of course, bringing our employees with us and, where appropriate, our community partners.'[200] Never mind the language (I particularly like the cryptic 'where appropriate, our community partners', by which I imagine is meant the museum's general audience), it is quite clear that this is no longer sponsorship but a business transaction that returns to sponsors the exact benefit equivalent of their cash contributions, an exercise in mutual, bank–museum brand enhancement. This is not sponsorship; it is renting out a museum as a glamorous networking venue.

All of the new museum's activities are first considered from a financial perspective. The museum's public-interest mandate is interpreted in ever narrower ways, ultimately only to serve the institution's self-interest. Other museums are no longer viewed as colleagues but as cash cows from which origination fees for exhibitions and, increasingly, fees for loans of works of art can

199
The Guggenheim Museum found itself in particularly dire straits, but many other American and European museums (including the British Museum and Tate Modern) were likewise affected.

200
Karina Robinson, 'Banking Matters: Banks Getting Deeper into the Art World', *International Herald Tribune*, January 1, 2007.

be milked. Whenever there is a conflict between the financial demands of the new museum and the old museum ethos, financial demands inevitably take precedence, because financial concerns have to be addressed immediately while questions of ethos can be debated forever, compromised, obfuscated or ignored.

The great danger in behaving like a business is that ultimately one will be treated like one. It is conceivable that, over time, the entire special status of the museum may be lost: state-funding, tax concessions, public trust – everything that made museums possible – might one day be denied by a politician who could justifiably claim that no difference exists between a museum and any other commercial enterprise. In a crisis, having traded the hard currency of public trust for corporate dreams, the museum may no longer be offered help but will be taken at its own word and allowed to fail – just like any other business that doesn't live up to market expectation. At this point, it will be too late to invoke the special pact between museum and public. Everybody will have forgotten.

Do so many problems, so much discontent, so much unease, not point to a more fundamental flaw at the heart of the new museum and the democracy of spectacle it espouses? I believe that the democracy of spectacle is, in fact, a contradiction in terms, an oxymoron. Born out of radical revolutionary politics, the public museum is vested with extraordinary powers and weighty responsibilities: to establish and uphold the cultural framework that provides the backdrop of all social and political discourse. To exercise these powers responsibly, ethically and for public benefit is the museum's central aim. It needs to encourage informed, empowered, independent-minded participant-visitors, who in turn are willing to be informed further, to have their knowledge expanded, their horizons opened and their curiosity affirmed. This is the pact between the museum and its visitors and, by extension, between the museum and society. To discharge its duties and retain the public trust should be the museum's main goal, the single consideration that over-rules all others.

There should be no limit on the intellectual ambition the museum has for its audience. Spectacle, however, relies on a passive consumer who is offered ever-escalating stimuli, yet nonetheless remains disengaged, bored and dissatisfied. Spectacle, in

the final analysis, is anti-democratic (and it is no coincidence that it plays such an important role in totalitarian society: it trains passivity and propagates ignorance). This is where the democracy of spectacle in the museum collapses. It perverts the museum's original idea by placing the institutional interest above the visitor's. It eschews public responsibility and holds itself accountable to no one. It is an abdication of the museum's historic duty and it will ultimately lead to its downfall. But it is not yet too late. Public trust is frayed but has not been completely eroded. In order to stop the rot, directors must set aside their corporate fantasies, abdicate their dreams of eternal growth and limitless expansion, renounce their big-business swagger. It is time for architects to put works of art first and architecture second; time for trustees to reign in their CEO directors and call them to account; time for politicians to stop insisting that museums serve social or political purposes (be they economic or regenerative) instead of supporting institutions for their own sake.[201] It is time for curators to follow their scholarly instincts and to reclaim their power (vested in them by the public). It is time for museums to return to their true business: preserving what lies in their care, and furthering knowledge. It is time for museums to empower, challenge, thrill and uplift their visitors, without compromise or shortcuts, always remaining aware of their duty and mindful of their privileged status in society. Lisa Jardine is wrong when she says: 'It is certainly not our job to be elitist'. It is the museum's *raison d'être*: to be elitist for everybody.

September 2008

01
See: Tony Blair's speech
on the arts, given at Tate
Modern, London, on
March 6, 2007, as reported
in: Charlotte Higgins,
'Blair Reminisces about
Labour's "Golden Age"
of the Arts', *The Guardian*,
March 6, 2007, p 18.

Published in 2015 by Ridinghouse
in association with Dublin City Gallery
The Hugh Lane on the occasion of

Sleepwalkers
Dublin City Gallery The Hugh Lane
2012 – 2014

Dublin City Gallery The Hugh Lane
Charlemont House
Parnell Square North
Dublin 1
Ireland
www.hughlane.ie

Curated by Michael Dempsey
Assisted by Logan Sisley and
Marysia Wieckiewicz-Carroll

Dublin City Gallery The Hugh Lane is
most grateful to the *Sleepwalkers* artists:
Clodagh Emoe, Sean Lynch, Gavin
Murphy, Linda Quinlan, Jim Ricks, and
Lee Welch; to Robert Ballagh, Sheena
Barrett, Black Church Print Studio,
Stephen Burke, Simon Cummins,
Oliver Dowling, James Hanley, Kevin
Kavanagh Gallery, Natalia Krause,
David Eager Maher, Modern Art Oxford,
Padraic E. Moore, Kevin Powell, Project
Arts Centre, and Amanda Ralph; to
Michael Dempsey, Head of Exhibitions
who curated the project, assisted by
Logan Sisley, Exhibitions Curator; to
exhibition curator interns Marysia
Wieckiewicz-Carroll and Steven
McGovern; to Margarita Cappock, Head
of Collections and Steven McGovern for
their support in the project; thank you to
Simon Critchley, Marysia Wieckiewicz-
Carroll, Michael Dempsey, Chantal
Mouffe, and Karsten Schubert for their
illuminating texts; to our collection care
team, attendants and gallery staff.

Ridinghouse
46 Lexington Street
London W1F 0LP
United Kingdom
www.ridinghouse.co.uk

Ridinghouse Publisher: Doro Globus
Publishing Manager: Louisa Green
Publishing Assistant: Daniel Griffiths

Distributed in the UK and Europe by
Cornerhouse
70 Oxford Street
Manchester M1 5NH
United Kingdom
www.cornerhouse.org

Distributed in the US by
RAM Publications + Distribution, Inc.
2525 Michigan Avenue Building A2
Santa Monica, CA, 90404
United States
www.rampub.com

For the book in this form © Ridinghouse
 and Dublin City Gallery The Hugh Lane
Texts © the authors
All images courtesy Dublin City Gallery
 The Hugh Lane unless noted on p.198

Edited by Michael Dempsey
 and Logan Sisley
Copyedited by Melissa Larner
Proofread by English Editions
Designed by Tony Waddingham
Printed in Belgium by Cassochrome

ISBN 978 1 905464 98 2

Comhairle Cathrach
Bhaile Átha Cliath
Dublin City Council

Ridinghouse